Colored Pencil
Solution Book

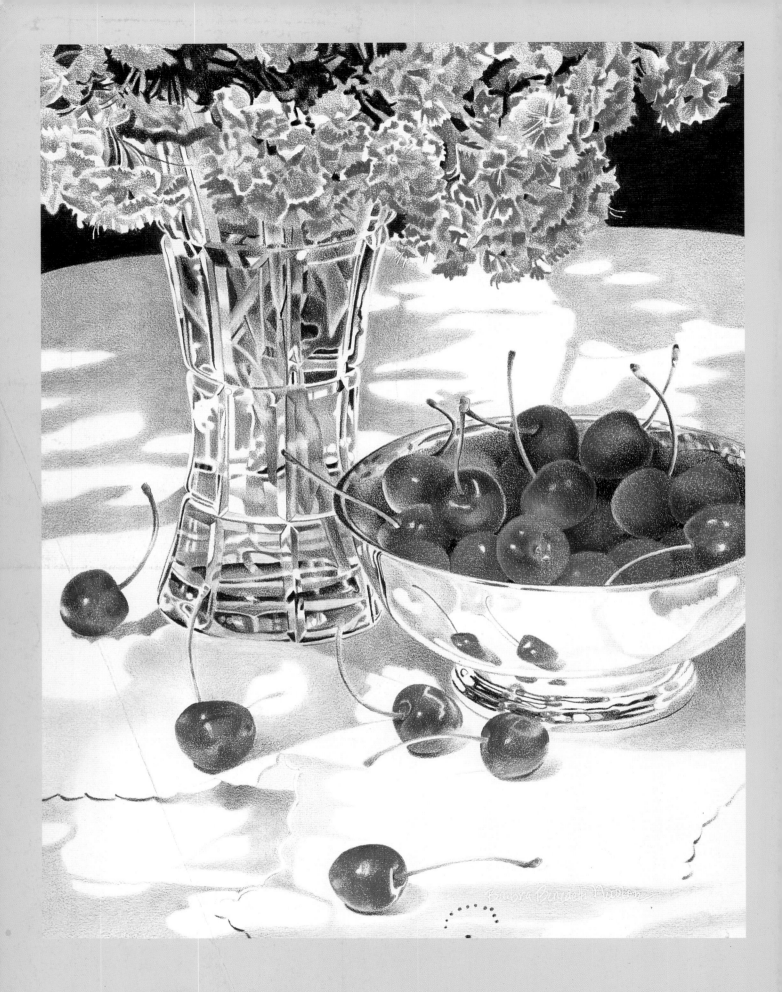

Colored Pencil
Solution Book

Janie Gildow

&

Barbara Benedetti Newton

NORTH LIGHT BOOKS
CINCINNATI, OHIO
www.artistsnetwork.com

ABOUT THE AUTHORS

Janie Gildow is a graduate of Ohio State University with a bachelor of science degree in art education. She taught high school art in the public schools until 1996 when she became a full time professional artist. In 1991 Janie "rediscovered" the colored pencil and recognized its enormous potential in her work.

Her art has been published in *The Artist's Magazine*, in *American Artist* and in eight books to date (including *The Best of Colored Pencil 2, 3, 4 & 5*). Janie also appears in *Who's Who of American Women*, *The World Who's Who of Women*, and the *International Who's Who of Professional and Business Women*.

Janie teaches colored pencil workshops in cities throughout the United States, and currently works with Sanford Prismacolor presenting the colored pencil to educators.

She is a Signature Member of the Colored Pencil Society of America and holds its 5-Year Award, as well as numerous awards in local, national and international competitions.

Janie's work appears in several sites on the World Wide Web. Visit her personal Web site: www.erinet.com/jagildow.

Janie currently resides in Ohio with her husband, Joe, and their two cats: Bentley and Buzzbee.

Barbara Benedetti Newton attended art school in Seattle, Washington, and started her art career in 1966 as a fashion illustrator working in black and white. More than twenty years later, after raising two children, she discovered the joy of color through colored pencil and began making art again.

Following a workshop with Bet Borgeson, Barbara's love of colored pencil led to a focus on fine art and commitment to the Colored Pencil Society of America as a Charter Member, Signature Member, Membership Director and President. She remains active in the CPSA

Seattle chapter. Barbara is also a juried member of Women Painters of Washington and of Catharine Lorillard Wolfe Art Club, New York.

Barbara's award-winning work has appeared in *Creative Colored Pencil*, *Exploring Colored Pencil*, *The Best of Flower Painting 1 & 2*, and in all volumes of *The Best of Colored Pencil*. Articles featuring her work have been published in *American Artist* and *The Artist's Magazine*.

When not creating work for galleries and shows, Barbara instructs colored pencil workshops for all skill levels. Visit her Web site at www.halcyon.com/bina.

10 09 08 07 06 5 4 3 2 1

Library of Congress has Cataloged hardcover edition as follows:

Gildow, Janie
 Colored pencil solution book/Janie Gildow & Barbara Benedetti Newton.
 p. cm.
 Includes index.
 ISBN-13: 978-1-58180-026-5 (hardcover; alk. paper)
 ISBN-10: 1-58180-026-6 (hardcover; alk. paper)
 ISBN-13: 978-1-58180-919-0 (paperback; alk. paper)
 ISBN-10: 1-58180-919-0 (paperback; alk. paper)
 1. Colored pencil drawing—Technique. I. Newton, Barbara Benedetti. II. Title.

NC892.G55 2000
741.2'4—dc21 00-030558

Edited by Jennifer Lepore Kardux
Production Edited by Jolie Lamping
Designed by Wendy Dunning
Production Coordinated by John Peavler

The line drawings on pages 120-126 have been created so you can practice using your colored pencils along with the demonstrations in this book. Please feel free to copy and enlarge these drawings for this purpose.

ACKNOWLEDGMENTS

FROM JANIE

I extend my most heartfelt thanks to Joe (my husband and best friend) who put up with me without complaint during the entire writing of this book. He deserves sainthood.

Special thanks to Barbara Benedetti Newton, my talented and respected coauthor, who kindly agreed to join me and share the work in order to complete this book.

Other individuals to whom I owe more than I can possibly say: Vera Curnow, without whom none of this would have been possible; George Crown, for telling me I had what it took; Jan Baird, for my love of color; Ann James Massey, for inspiration, support and friendship; George Bussinger, who believes in the colored pencil as a serious medium; TransImage, my excellent color lab.

Jointly Barbara and I would like to thank Rachel Wolf for sharing our vision, and Jennifer Lepore Kardux, editor extraordinaire, for her tireless dedication, her enthusiasm and her appreciation of the colored pencil.

FROM BARBARA

For gentle guidance in helping us present all that we hoped to include, thanks to our editor, Jennifer Lepore Kardux. My heartfelt thanks to my husband, Jay, whose love and support enabled me to take on this project, and to Mollie who stayed beside me until it was time for her to leave. Special thanks to my coauthor, Janie Gildow who has been a pleasure to work with and whose courage, friendship and generosity will never be forgotten.

DEDICATION

FROM JANIE

To all of my students—past, present and future—and to the many who have requested that I share my knowledge and my love of the colored pencil with them in book form.

FROM BARBARA

This book is dedicated to all who have attended my workshops and encouraged me to put my words and work in book form. And to those who return to their love of creating art, as I did, through colored pencil.

TABLE OF CONTENTS

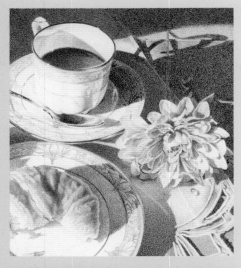

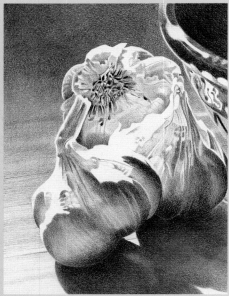

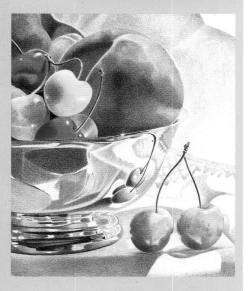

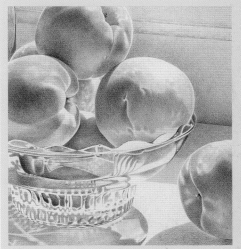

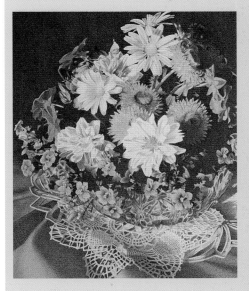

INTRODUCTION

Solving problems—that's what this book is all about. In it you'll find answers to your questions and solutions to your problems—and everything in here revolves around colored pencil.

As children we drew and colored with confidence and joy. As adults our artistic desire is to return to that level of certainty and pleasure. Many have chosen the colored pencil as the means. For us it is the long-sought solution. It provides us with the ability to speak from our hearts, to express ourselves through our art, and to share our love of detail and color.

This book is for all artists of all levels of achievement. In these pages you will find many helpful hints and suggestions—whether you are just picking up a colored pencil for the first time or whether the two of you are already old friends.

Learn how to set up your workspace and select your pencils and the tools you need. Find out about working on a variety of surfaces. Discover shortcuts and helpers that will make creating art with colored pencil easier.

Have you always wanted to know about composition? A whole chapter is devoted to it. You'll learn how to judge your work and the work of others.

Questions about color? Find the answers here. Become partners with the color wheel.

Want help with specific subjects? You'll find examples with easy-to-follow instructions that lead you step by step. Metal, glass, water effects, transparencies, textures, lace—all in these pages. What about problem subjects? We've analyzed and simplified them for you. Mistakes happen. We tell you how to fix them.

In the final section we've shared our line drawings with you. They make this book unique. Use them. They make it possible for you to concentrate on color application and technique—rather than on drawing. They let you start your journey through the wonderful world of the colored pencil *right now.*

We hope this will be one of the most frequently used and well-worn books on your shelf—that you will keep it near you for handy reference, and that you will come to love the colored pencil as we do. May you color with confidence and joy.

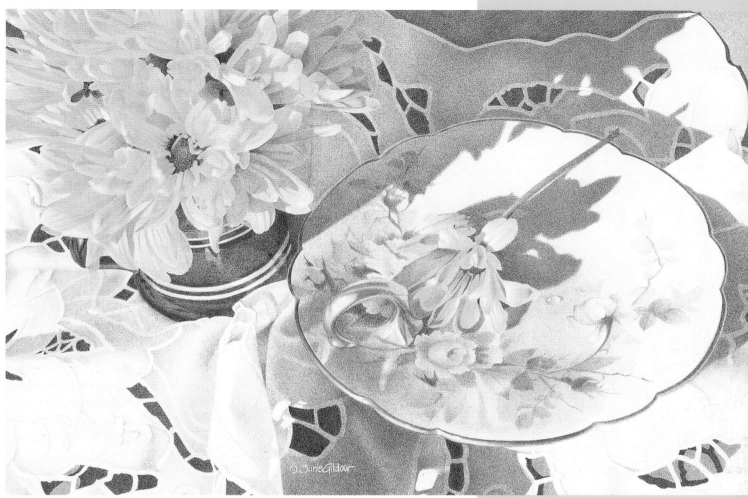

KAREN'S GIFT
Janie Gildow
Colored pencil on Fabriano Uno HP 140-lb. (300gsm)
12" × 18" (30cm × 46cm)
Collection of the artist

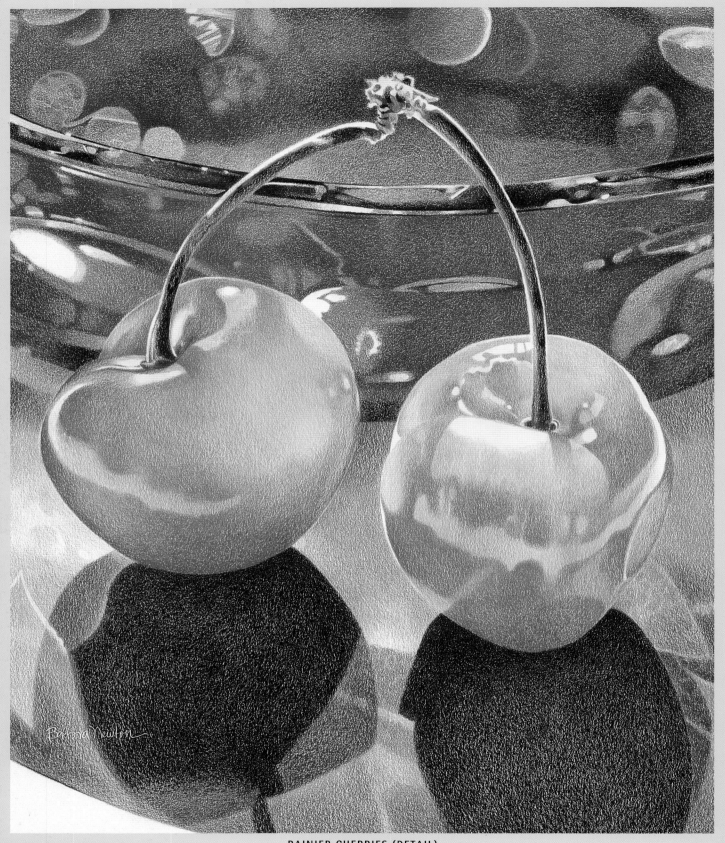

RAINIER CHERRIES (DETAIL)
Barbara Benedetti Newton
Colored pencil on Strathmore 500 Bristol Plate
21¾" × 16" (55cm × 41cm)
Private collection

start with a good setup

When you get ready to start producing colored pencil art, it's important to have a plan in mind: Where are you going? How do you intend to get there? Think about where you will work and how you will arrange your workspace. Consider the different brands of colored pencils—each with its own unique set of characteristics. In this chapter you'll find tips on choosing materials, tools and equipment. You'll learn how to store your pencils, how to make pencil holders, and you'll learn about pencil sharpeners, erasers and differences in drawing surfaces. Find out how to care for and store paper, and how to keep your work and work area clean. This chapter is all about getting started on the path to your adventure: creating art with colored pencils.

BARBARA'S STUDIO

JANIE'S STUDIO

HOW SHOULD I ARRANGE MY WORKSPACE?

DRAWING SURFACE

You will need a smooth, flat surface for working. It can range anywhere from a laptop piece of Masonite to a large adjustable drafting table. No matter what surface you choose, put some kind of cushion on it so that your colored pencil application will be smooth. An excellent investment is a vinyl drawing board cover. You can purchase this cover as a boxed roll from your art supply store, cut it to fit your drawing board and attach it with double-sided tape. Vinyl covers are also available in standard sizes. Attach a tray to the board to keep pencils, erasers and other equipment handy. Several sheets of paper, a piece of railroad board (an inexpensive 4-ply colored board made for posters and easily purchased wherever art supplies are sold) or tagboard (cream or white 2-ply lightweight flexible board used for making file folders) will also work.

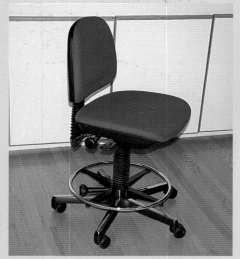

CHAIR

Your working posture is extremely important. Invest in a good chair that is adjustable both in height and back support. When working with colored pencil, sometimes hours go by where little moves except your fingers.

When you set up a studio, carefully plan to utilize your space for efficiency and comfort. Your studio needs to be a place you can't wait to get to each day, a place set up to help you be your most creative self. If your studio will include an office area for a desk, phone/fax, computer, scanner, copy machine and file cabinets, keep it separate from your art area. Then, either ignore the phone when it rings or consider a headset extension connected to your phone for taking calls while at your drawing table. This saves you from running with a handful of pencils to answer the phone, then leaving them on your desk, going back to drawing, looking for the pencils, getting up to

LIGHT

A good light source is a necessity. Natural light is always excellent, but an electric light with a spectrum-balanced bulb may be preferable because it makes working at night possible. If your studio has fluorescent lights, they too should contain spectrum-balanced bulbs. You can purchase ultraviolet shields for your fluorescent tubes at your local hardware store to prevent fading and deterioration of works on paper. Filter-Ray UV Shield for 48"-length (1m) lights can be ordered from Light Impressions Corporation, Rochester, New York; (800) 828-6216; www.lightimpressionsdirect.com.

retrieve them … you get the idea.

A spacious studio is a luxury but not a necessity when working with colored pencil. This medium is versatile and easy to use with so little mess and fuss that you can set up your work area virtually anywhere that is convenient. It is nice, however, to have a space you can call your own, where you can work relatively uninterrupted. All you need is a smooth drawing surface a bit larger than your work, something to sit on (unless you prefer to stand at a high drawing table), good light and a few tools. One successful colored pencil artist's studio was the space behind her living room couch; others use a portable drawing board at the kitchen table.

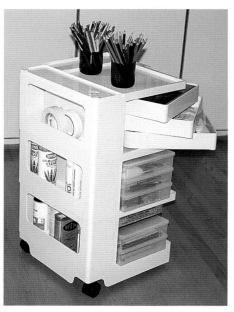

TABORET, SHELF OR MOVABLE TABLE

If you work with your drawing surface on an angle, having some flat storage near you is a necessity. A shelf, table or even an old microwave stand (especially if it is on casters) works well. You can also purchase a small portable stand called a taboret (tab -or -AY). It is one of the most useful items in the studio because you can store so many tools and supplies in a compact manner.

WHAT SHOULD I LOOK FOR WHEN BUYING COLORED PENCILS?

There are many brands of colored pencils on the market. Some are for coloring maps. Some are for making fine art. You need to buy the best fine art pencils you can afford. Each brand has its own unique characteristics and color palette. Purchase the largest set you can afford—or find a source where you can buy the pencils in open stock. That way you buy only the colors you need and you can replace them one at a time as you use them. (See the Colored Pencil Chart on pages 14-15 for characteristics of each brand of pencil.)

Consider the following characteristics when purchasing your pencils:

TRANSPARENCY—Is the pigment finely ground and the binder free from cloudiness?

LIGHTFASTNESS—Lightfastness is an important issue. No one wants to create art with colors that change and fade over time. Some colored pencil manufacturers consider the lightfast issue a priority and are working to make pencils as lightfast as possible. For now, it is a good idea to choose a palette of the most lightfast colors and to *never* hang *any* artwork in direct sunlight.

COMPATIBILITY—If you use more than one brand of pencils in any one piece of work, check them for compatibility by layering them together with one another and checking for transparency and coverage.

WAX—The wax-based pencil uses mostly wax in the binder. The wax is semitransparent and allows for layering on the drawing surface with each layer of color showing through the ones layered on top of it. One consideration in using wax-based pencils is the possibility of wax bloom. This phenomenon occurs with a heavy application of color. It is most noticeable on dark colors. With time and increased temperatures, the wax rises to the surface of the applied pigment and forms a cloudy white haze. It is preventable and correctable by using spray fixative. (See page 19 for more information.)

OIL—The oil-based pencil uses oil in the binder instead of wax. It is similar to the wax pencil and can be used in combination with many of the wax brands. Oil-based pencils will not produce wax bloom.

WATER-SOLUBLE—The water-soluble pencil uses water-soluble gum as a binder. It may be used in its dry form to draw or color, laying down pigment on the drawing surface. As the pigment is thinned by water and moved with a brush, the resulting appearance is that of a watercolor painting. In addition to dry-on-dry, water-soluble pencils can also be used wet-on-wet, wet-on-dry or dry-on-wet for additional effects.

CENTERED LEAD
Look at both ends of the pencil. Is the lead centered? If the lead is not centered, the pencil will not sharpen evenly and the lead or the wood may splinter. Some pencils are finished on one end, however, which makes checking the lead impossible.

SIMILAR WOOD HALVES
Look at both ends of the pencil to check the wood. Do the two halves look similar? If they look very different, choose another pencil. Halves that are too dissimilar will not sharpen well; they may expose lead unevenly, weakening or breaking it.

PACKAGING
Colored pencils vary in their packaging, from cardboard or wood boxes to metal tins.

STRAIGHT SHAFT
Sight down the pencil or roll it across a flat surface. If it looks curved or wobbles when it rolls, select another pencil. Curved pencils do not sharpen evenly.

COLORED PENCIL CHART OF CHARACTERISTICS

This colored pencil chart shows some of the important characteristics of different brands of pencils. Notice that each pencil brand (except Prismacolor) has been assigned an abbreviation.

Throughout this book, whenever pencils other than Prismacolor are used, they will be accompanied by their abbreviation to alert you to their brand. We have primarily used Prismacolors in the making of this book, due to their wide use and easy accessibility, and as they appear so often here, they will be referred to by name only (no abbreviation).

	Rexel Derwent (Great Britain)	Bruynzeel (Holland)	Lyra Rembrandt (Germany)	Caran d'Ache (Switzerland)
Brand				
Style	Artists	Fullcolor	Polycolor	Pablo
Cross section shape	●	●	●	⬡
Hardness	Med.	Med.	Soft	Soft
Colorless blender	No	No	Yes	No
Manufacturer's lightfast marked	No	No	No	No
Flat end	Yes	No	No	No
Presharpened	Yes	Yes	Yes	Yes
Casing finish	Paint color of lead	Natural with end color	Natural with end color	Paint color of lead
Casing	Cedar	Cedar	Cedar	Cedar
Lead diameter	4.0mm	3.5mm	3.8mm	3.7mm
Pencil diameter	8mm	7mm	6.5mm	6.5mm
Colors	120	100	72	120
Binder	Wax	Veg. Oil	Veg. Oil	Oil
Name abbreviation	DA	BR	LY	CA

Faber-Castell (Germany)	Sanford (USA)	Rexel Derwent (Great Britain)	Sanford (USA)	Brand
Polychromos	**Prismacolor**	**Studio**	**Verithin**	**Style**
				Cross section shape
Soft	Soft	Hard	Hard	**Hardness**
No	Yes	No	No	**Colorless blender**
Yes	No	No	No	**Manufacturer's lightfast marked**
No	Yes	No	No	**Flat end**
Yes	No	Yes	Yes	**Presharpened**
Paint color of lead	Paint color of lead	Black with end color	Paint color of lead	**Casing finish**
Cedar	Cedar	Cedar	Cedar	**Casing**
3.8mm	3.8mm	3.5mm	2mm	**Lead diameter**
7.5mm	7mm	6.5mm	6mm	**Pencil diameter**
120	120	72	36	**Colors**
Oil	Wax	Wax	Wax	**Binder**
PC	None	DS	VE	**Name abbreviation**

WHAT KINDS OF PENCIL SHARPENERS WORK BEST?

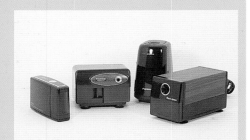

BATTERY-POWERED SHARPENER (above, left)

This is an excellent choice for traveling. It is self-contained with its own waste receptacle and reasonably rapid sharpening. Battery-powered sharpeners give a sharp tip, but the pencil point may be shorter than those made by electric sharpeners. Be sure to push the pencil down into the sharpener with some force in order for the sharpener to work as it is intended.

ELECTRIC SHARPENER (above right)

The electric pencil sharpener sharpens quickly with the insertion of the pencil and gives a needlelike appearance to the pencil point. Make sure you purchase one with an auto stop feature or you may see the sharpener eat your pencil! Electric sharpeners are available in different sizes and shapes—and prices. Choose a sharpener with a large enough opening to accept larger-diameter pencils.

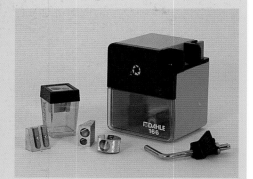

HANDHELD SHARPENER (above left)

This kind of sharpener is a good choice when you need to work away from your studio area, because it is small and doesn't require electricity or batteries. Purchase one with replaceable blades and its own waste receptacle to catch shavings. Some pencils are bigger in diameter than others so consider a sharpener with two openings of different sizes.

STATIONARY SHARPENER (above right)

Purchase a stationary sharpener made for the pencil artist rather than for school or office use. The stationary sharpener must be fastened securely to a flat substantial surface.

To get even, consistent color application, you need to keep your pencil points very sharp so that they color down into the paper tooth. This requires frequent sharpening.

Pencil Stubs

As you sharpen, a time will come when the pencil is too short to insert into your sharpener and hold on to. This is a stub. Pencils can be sharpened to stubs of various lengths, depending on the pencil brand and kind of sharpener you use to sharpen them. Look for a sharpener with a relatively short throw (the distance from the opening to the blades). The shorter the distance, the shorter the stub will be that you have to throw away. (The Panasonic model KP310 is excellent for allowing you to sharpen the pencil down to a short usable length of stub.) Or you may want to switch to a handheld sharpener for stubs.

Pencil Extenders

Pencil stubs can be inserted into pencil extenders to lengthen the shaft, giving you better leverage and less cramping. Unfortunately, extenders don't hold the stubs with a firm enough grip that you can sharpen the extended pencil in an electric sharpener. When inserted into the sharpener, the stub just spins in the extender.

Gluing Pencils Together

Colored pencil artists can't squeeze the last dollop of paint from a tube. A shaft of color you can't get to is always left in the pencil stub. For pencils with flat ends, gluing the stub to a new pencil is a way to use all of the pencil. Apply a superglue for wood as directed and butt the flat end of the stub to the flat end of a new pencil of the same color. Make sure you have a strong bond and then continue sharpening through the stub and into the new pencil. When the new pencil becomes a stub, repeat the gluing process.

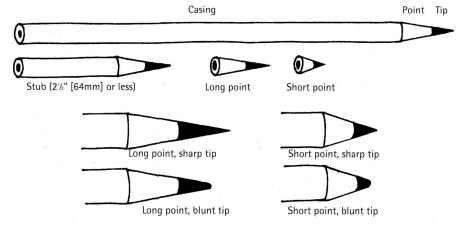

Casing — Point — Tip

Stub (2½" [64mm] or less) Long point Short point

Long point, sharp tip Short point, sharp tip

Long point, blunt tip Short point, blunt tip

WHAT SHOULD I USE TO REMOVE COLOR?

Kneaded Eraser

The kneaded eraser warms and softens to the hand and becomes pliable. It should be pressed against the area of color to be removed, then pulled quickly away. It can also be used to pick up color chips that fall from the pencil onto the artwork. A kneaded eraser can be used until it becomes overloaded with color or graphite.

Reusable Adhesive

Also called *mounting putty*, this product is used to lift or soften colored pencil and to lighten graphite sketch lines. It should be dabbed, not rubbed, on the area of colored pencil you wish to lift. It performs in a similar manner to a kneaded eraser but is softer, more pliable and, depending on the brand, more aggressive. Like a kneaded eraser, reusable adhesive should be kneaded, stretched and pulled to absorb colored pencil as well as graphite.

White Click Eraser

The white click eraser is a pencil-sized cylinder of soft white eraser. It is encased in a plastic tube that allows it to feed out bit by bit, or click by click (hence the name). You can use it to blend layered pencil (see more on blending, page 43). Use this method only on lightly layered pencil—not on any heavy application of color.

White Plastic or Vinyl Eraser

The white plastic or vinyl erasers are similar to the eraser product in the click eraser but range from extra soft to quite rigid. They can be cut into shapes or wedges to erase with more precision. They are used mainly to clean up borders and white areas but can also be used for special effects on colored pencil by producing a soft streaking effect. They are known for erasing without abrasion and work on most types of paper.

Electric or Battery-Powered Eraser

The electric or battery-powered eraser enables you to erase large or small areas of color quite well and very quickly. Erasing with a handheld eraser can produce an ugly smear of wax called *slurry* which is impossible to remove from the drawing surface. The speed with which the electric or battery-powered eraser spins eliminates the formation of slurry. It can usually remove most layered and burnished pigment leaving only a slight stain of color.

You may have to run the eraser over sandpaper or toothy paper at regular intervals to remove the wax buildup on the eraser. You may also want to sharpen the erasing cylinder to a point for precision erasing. Do this with an art knife or by holding the point at an angle on sandpaper or toothy paper while the eraser is running.

Tape

Colored pencil can also be removed by using tape. Masking tape works for lifting large areas, but for critical work, you'll find a transparent, removable tape (like Scotch Magic Plus) works best. For precision removal, apply the transparent tape and, with a pointed but not sharp object (like a ballpoint pen), firmly trace over the detail you want to remove. When you lift the tape, the detail will be picked up by the tape. For larger or random areas, apply masking tape and press with your finger or thumb to warm the applied pencil. Remove the tape. Color will be stuck to the tape.

Frisk Film

This product works the same way transparent tape does but is more gentle. You don't have to be as careful when you use it because it won't lift color as dramatically as tape. It is available in rolls or sheets and can be used to remove color or to protect white areas.

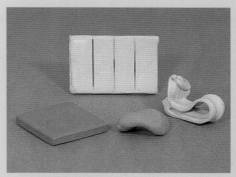

PLIABLE LIFTERS

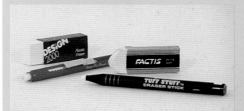

PLASTIC AND CLICK ERASERS

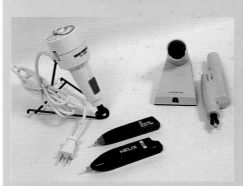

POWERED ERASERS

TAPE AND FILM

WHAT SHOULD I KNOW ABOUT PAPER?

SMOOTH PAPERS
A paper with a hot-press (plate) finish is smooth (some would describe it as slick) and will not hold as much colored pencil pigment as a paper with more tooth or texture.

ROUGH PAPER
You will find that the appearance of colored pencil applied to a rough paper will vary depending on the texture or pattern of fibers.

Hot-Press Surface

Hot-press surfaces are smooth with very little tooth (surface texture). Some are actually slick, which makes erasing more difficult. Hot-press papers accept less color. On them, the buildup of color is subtle and, if not applied very lightly, will quickly acquire a burnished appearance. Hot press is sometimes called *smooth* or *plate*.

Cold-Press Surface

Cold-press papers accept pencil well, and you can usually apply as many layers as you want to them. Being rough and hardy, they hold up well to erasing. The cold-press surface is usually labeled *vellum* or *regular*.

Rough Surface

Rough surfaces have definite hills and valleys and a very observable pattern. They accept a lot of color, but if you want solid coverage or a more smoothly blended appearance, choose a paper with less texture. Rough surfaces tend to eat pencils.

Prepared Surfaces

Sanded paper (made for pastels) and **Sabretooth** (colored paper with a raspy surface) are used by some colored pencil artists. The grainy surface accepts a great deal of color, but at the same time, it also tends to wear down pencils quickly.

 Clayboard (a multimedia clay-coated board) is available in smooth and textured surfaces. Coated boards are sturdy and made for additive application (oil, pastel, ink, watercolor, acrylic, tempera, colored pencil) and also for subtractive work (sgraffito).

Thickness or Ply of Paper

If you plan to mat, frame and sell your work, use thicker papers (2-ply or greater) and boards for their durability and lasting quality. If you plan to transfer your sketch onto your working surface (rather than drawing it freehand), lower-ply papers allow you to trace or transfer your sketch by use of illumination, but with heavier boards, your sketch will have to be transferred by another means, such as transfer paper.

Rag Paper

Rag paper is made from fibers of nonwood origin, such as cotton rags, cotton linters (the fibers that are left on the seed after the long fibers used for textiles have been removed) or linen or cotton pulp.

pH Neutral

The acid/alkaline balance of paper made from any kind of pulp is perfect with a pH of 7.

Acid Free

Paper that has a greater ratio of alkaline to acid (or a pH from 7.5 to 8.5) can be called *acid free*. Acid-free paper is made from plant fibers (cellulose) including wood and cotton. Acid is paper's greatest enemy because it attacks the fiber strands, which then come apart, and the paper deteriorates. In nature, fiber strands are held together by *lignins*, which act as a glue. When the plant dies, the lignins develop an acidity that must be removed or neutralized before the paper is made.

Alpha Pulp

Alpha pulp consists of plant fibers from which the lignins have been removed to the point where a long-lasting paper can be made from it.

Buffer

A buffer is a chemical (alkaline substance) added to paper pulp to retard (or neutralize) the development of acid over time. Buffers have a definite life and will eventually disappear.

WHAT OTHER TOOLS WILL COME IN HANDY?

Colorless Blender

New to the colored pencil market is the colorless wax blender. It looks like a pencil, and the lead is made of wax, but it contains no color pigment. This tool allows you to blend or burnish an area without changing its color (see page 43 for more on burnishing). Currently there are two available: the Prismacolor Colorless Blender (wax-based) from Sanford, and the Splender (oil-based) by Lyra Rembrandt.

Art Stix

These sticks of colored pencil pigment look like pastel sticks. Their colors are formulated to match and coordinate with the Prismacolor pencil colors. They are used primarily to lay in large areas of color in a broad, spontaneous manner.

Glue

To get maximum mileage out of a colored pencil, try gluing the stub onto a new pencil of the same color, aligning flat ends carefully. Use a superglue that bonds wood.

Erasing Shield

This useful tool helps protect the surrounding area while you are erasing detail or lifting color. The various-shaped openings allow you to select just the area you want to erase. This tool is excellent for lifting color and cleaning up edges and can be used with reusable adhesive, click, kneaded, battery-powered and electric erasers.

Fixative

This product is used to prevent wax bloom (see page 13 for more on wax bloom). When you complete a piece of colored pencil art, apply several light coats of this spray. Do this outdoors or with excellent ventilation.

Fixative may alter the appearance of the colors in your work, especially the violet range. Before using it on your original art, make a test patch of color on another piece of paper. Workable fix allows you to spray your work, fixing the color at convenient intervals.

Brushes

Drafting brushes have a long handle and generous length of bristles; some are coarser than others. Brushes are useful for keeping your work area clean.

The 4-inch (102mm) hake watercolor brush is like several individual brushes glued together side by side to form one wide flat brush. The goat-hair bristles are white and very soft, so they do not scratch, pull up or smear your work.

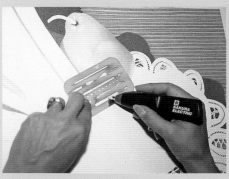

ERASING SHIELD IN USE

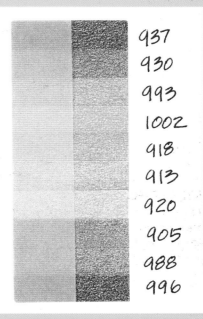

937
930
993
1002
918
913
920
905
988
996

TEST STRIP OF COLORS WITH FIXATIVE
Apply color full-value; cover half of each color and spray the exposed area with fixative. Check for any changes.

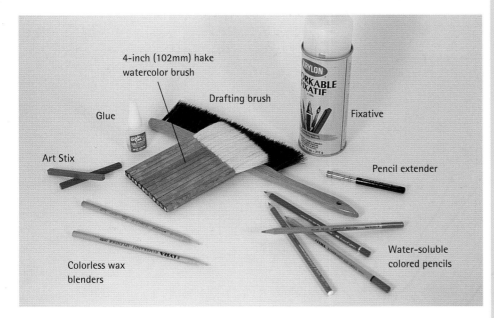

4-inch (102mm) hake watercolor brush

Glue

Drafting brush

Fixative

Art Stix

Pencil extender

Colorless wax blenders

Water-soluble colored pencils

HOW CAN I MAKE DRAWING EASIER?

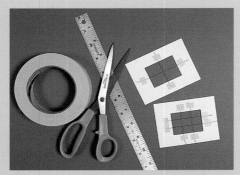

MAKING A VIEWFINDER
To make a viewfinder, you will need a piece of paper, a pencil, scissors, art knife, thread (to give your viewfinder a grid), ruler and masking tape. Cut the piece of paper to a proportion that is the same as your final composition. It should be a size that easily fits the hand. Cut a window opening of 2" x 2" (5cm x 5cm) or less in the viewfinder and attach a thread grid that will help you arrange your composition and transfer it to paper.

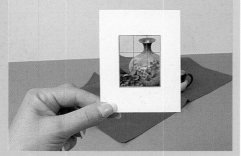

ISOLATING THE COMPOSITION
Use the viewfinder to isolate your composition. Look through the window and move the viewfinder toward and away from you until the view you want is isolated in the window.

Viewfinders
The world is filled with distracting elements. To more easily see and isolate only those elements needed for a composition, you can use a viewfinder. The viewfinder, or mini-picture-frame, enables you to select a portion of your viewing area and see how it will look as a possible composition. Adding thread indicators to your viewfinder will make it easier to transfer what you see into a drawing.

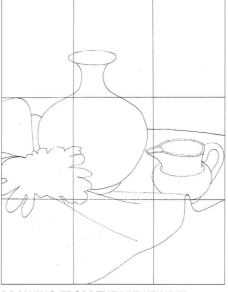

DRAWING FROM THE VIEWFINDER
Divide your paper into the same number of sections as determined by the thread indicators on your viewfinder. Draw what you see in one section of the window on the corresponding section of your paper.

COLORED ACETATE VALUEFINDER
Another useful tool in judging values is colored acetate, transparent red or green. You can make a colored acetate valuefinder by cutting two pieces of sturdy paper, each approximately 6" × 9" (15cm × 23cm) and sandwiching the colored acetate in between. Or use this same idea, sandwiching the colored acetate in a plastic slide sleeve.

Valuefinders
Sometimes values (light to dark) become hard to judge. Color complicates value determination. Is this color lighter than that color? How much darker than the drawing surface is this color or value? Isolating the values in question helps to determine relationships.

HOLE–PUNCH VALUEFINDER
The hole-punch valuefinder makes it easy to judge values. Punch holes into light-value (white), middle-value (gray) and dark-value (black) pieces of paper. Compare the values of objects to each other and to the lightness or darkness of the valuefinder.

Using CPR (Comparison, Proportion and Relationships)

A pencil (or any other long and relatively thin object) can be used for comparison, proportion and relationships to aid you in drawing.

Anglefinder

When drawing realistically, it is vital to use correct perspective. Seeing the perspective and then drawing it correctly can sometimes be difficult and confusing. Creating your perspective with a straightedge and vanishing point(s) works well when you are making a mechanical drawing. But perspective for artists is done differently.

Trying to use actual vanishing points distorts and exaggerates angles, making the drawing look unreal. What you as the artist really need to do is to exactly duplicate the angles you see. Making and using an anglefinder will enable you to draw angles in correct perspective without using a ruler.

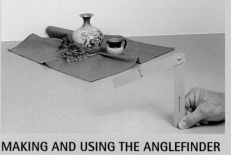

MAKING AND USING THE ANGLEFINDER

Make the anglefinder from two pieces of tagboard or posterboard roughly ¾" × 6" (2cm × 15cm). Place the pieces one on top of the other, and fasten them together at one end with a paper fastener.

Find the angle you wish to duplicate and, holding one leg of the anglefinder vertical, swing the other leg to exactly match the angle in question.

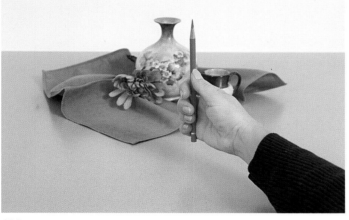

CPR

Hold the pencil (pen, brush, straw, etc.) at arm's length, so that its point aligns with the height or width of the object you wish to compare. Close your fist around the pencil with your thumb pointing up, resting on the length of the pencil. Now slide your thumb up or down so that its tip aligns with the other end of the length in question. As you sight down your arm, the length you wish to compare should fit between the pencil tip and the tip of your thumb.

Keeping the pencil at arm's length, turn it to lay its length along the second measurement. Now you can compare the first length to the second. To keep correct proportions and relationships, use this method to measure and compare as you draw.

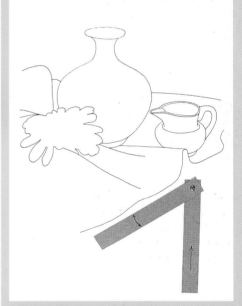

TRANSFERRING YOUR ANGLE

Keeping the vertical leg in position, lower the anglefinder to your drawing surface. The angle of the second leg is the correct angle for your view. You can eyeball the angle—or you can actually use the leg as a straightedge and draw along it.

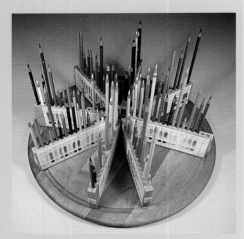

ALMOST PERFECT PENCIL HOLDER

This pencil holder is made of four sections. Each section is made of two pieces of wood, hinged together at one end to make a **v** section that opens like a book. You can make one or many **v** sections depending on the number of pencils; one section holds thirty-two pencils, sixteen on each side.

To make one section, gather two pieces of pine or other wood, 3½"-high × 8½"-long × ¾"-thick (9cm-high x 22cm-long x 2cm-thick); and one 3"-high × 1"-wide (8cm-high x 3cm-wide) light-gauge butt hinge or piano-type hinge with ⅜" (10mm) screws. Piano hinges are available at your hardware store in lengths 30" (76cm) and longer. Cut the hinge with a hacksaw to desired the length. You'll also need a drill with a ⁵⁄₁₆" (8mm) drill bit or larger. (Check the diameter of your brand of pencil.)

Use a graphite pencil to indicate the placement of each hole, spacing them ½" (1cm) apart at center along the ¾"-thick (2cm) side of the wood. Drill the holes 1½" (4cm) deep to hold the pencils upright. After drilling the holes, sand lightly and attach the hinge to join the two pieces of wood together at one end.

Four of these **v** sections fit nicely on top of a 21" (53cm) lazy Susan that turns for easy access to pencils and small tools (erasers, removable adhesive, etc.) stored in the **v** of each section.

don't drop pencils!

This may cause the lead to break within the shaft, and you won't realize the problem until you sharpen your pencil and a short section of the lead is loose and falls out. If you're lucky, that will be the only break, but unfortunately, pencils seem to break in more than one place within the shaft.

Pencil Holders

When you are new to the medium of colored pencil, the cartons or tins that your pencils came packaged in from the manufacturer will be sufficient storage. But as you collect favorite colors or various brands, you'll need additional storage. Small glasses, jars or cans are useful to store pencils by color, value or brand.

You might try your hand at making the versatile Go-Anywhere Pencil Holder (below) or the Almost Perfect Pencil Holder (left). These two holders work for daily use or travel.

Paper Storage

Paper is moisture-sensitive and does not react well to changes in temperature or humidity. It's a good idea to store your paper away from direct sunlight and on a firm, flat surface that is not affected by these changes. Flat files (shallow metal or wood drawers) are excellent for paper storage. You can buy them or make them. Or you can use any flat shelf large enough to hold your paper.

If you don't have access to a flat shelf that is deep enough, get a large flat card-

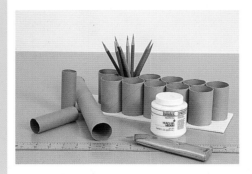

board carton with a lid, put your paper inside and slide it under your bed. (Ask your art supply dealer for an empty carton.) If you store your paper in large plastic bags, it will stay dust-free, but make sure there are no wrinkles in the bags to affect the paper's flat surface. If you stack papers of different dimensions on top of one another, you'll risk having some of your paper bend or curl. Separate papers of different sizes with large pieces of heavy cardboard and keep the larger pieces of paper toward the bottom.

Since working on colored pencil is so time-consuming, it's also probably a good idea not to buy too much paper at one time. Buy it by the carton only if you crank out a lot of work in a short time. Otherwise, purchase just a few sheets at a time.

Labeling Paper

White papers can look alike. To identify white papers that are stored together, write lightly along one edge in graphite or put removable labels on paper. You can also lightly write the word *back* on the back of the sheet. That way, later on, you'll know which side is the front and which is the back of the sheet or the usable scraps.

GO-ANYWHERE PENCIL HOLDER

Cut measured lengths (each approximately 4" [10cm] long) of cardboard tubes (from wrapping paper, paper towels, shop towels, etc.).

Dip one end of each tube in Liquitex heavy gel medium and place tubes in any combination (gel end down) on a piece of foamcore board cut to a size that accommodates the number of tubes you need, leaving a little margin around each of the four sides. It's a good idea to have at least one tube for each of the twelve major color families plus three to four more for the achromatics (black, white, grays) and whatever other extras you might have.

Let dry overnight and the holders are ready for action the next morning. The gel medium dries to clear. The tubes are easy to label with a marker.

HOW CAN I KEEP MY WORK AND SUPPLIES CLEAN?

Tape the Edges of Your Drawing

Before you start to color, tape around the perimeter of your image on your drawing paper. This provides you with definite, clean edges. Be sure to first test the tape on your drawing surface. The tape should lift easily without harming the surface. Scotch Safe-Release masking tape is a good one to use.

Make a Working Mat for Your Drawing

A working mat can be made from any paper that is 6"–8" (15cm–20cm) larger in height and width than your drawing. Cut an opening in the center as you would cut a mat for framing. The opening should be ½" (1cm) larger on all sides than your drawing. The extra ½" (1cm) all the way around enables you to tape the working mat to your drawing paper. Apply the tape right up to the edge of the drawing. The mat protects the area outside of your drawing and is a convenient place for color swatches and notations.

Clean Your Pencils

Attach a 3-inch (76mm) brush to your electric pencil sharpener with reusable adhesive so that the bristles extend beyond the front of the sharpener. Each time you sharpen a pencil, drag the pencil through the bristles to remove color and wood particles, or keep a paper towel handy to wipe off your pencil points when needed.

No Food Allowed

Having food or drink anywhere near your work area is risky. Grease is not only impossible to remove from the drawing surface, but colored pencil won't stick to it. Liquids are easy to spill, and sugar or salt will make your work sticky and will scratch it. Blowing to remove small color chips may cause harm to your work, as your expelled breath may contain droplets of saliva.

Clean Your Sharpeners

HANDHELD SHARPENER—Replace dull blades as needed. If a pencil point breaks off and sticks in the sharpening chamber, a paper clip or art knife can help remove it. Avoid touching the sharpener blade with this tool, as doing so may dull the blade.

ELECTRIC OR BATTERY-POWERED SHARPENER—The best and quickest way to maintain a clean electric sharpener is to sharpen a hard lead graphite pencil in it occasionally.

For a thorough cleaning, clean the grinders by dipping a dowel rod (of approximately the same diameter as a pencil) into rubber cement thinner or lighter fluid. Then sharpen the dowel in the pencil sharpener. This is not recommended as an everyday—or even frequent—practice. It should be done only occasionally.

If a colored pencil tip (pigment only, not wood casing) breaks off inside your electric or battery-powered sharpener, insert a graphite pencil with firm pressure. It will sharpen through the colored pencil pigment and into the graphite.

Use a Slip Sheet

A slip sheet protects your work from the heat and moisture of your hand when drawing. A slip sheet can be any material that protects your drawing surface but doesn't pick up color from your drawing.

Glassine works well. It can be purchased in sheets from art supply stores. It is the same material that sheets of stamps come in at the post office.

The cover from a lined-paper notebook also works as a slip sheet. Use it slippery side down to keep the chips of color from sticking to it. Use it matte side down to keep it from slipping off an inclined board, but clean the matte side frequently with your kneaded eraser or reusable adhesive. The plastic covers from newer lined notebooks are perfect. They are thin enough to be used easily, thick enough to protect the work, yet tough, durable—and best of all—washable.

Photographs also work as a slip sheet. Place the picture side down against your work. The glossy surface will not pick up color.

A working mat is in place here.

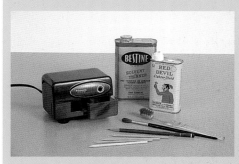
Keep your sharpeners clean.

A plastic notebook cover makes a good slip sheet.

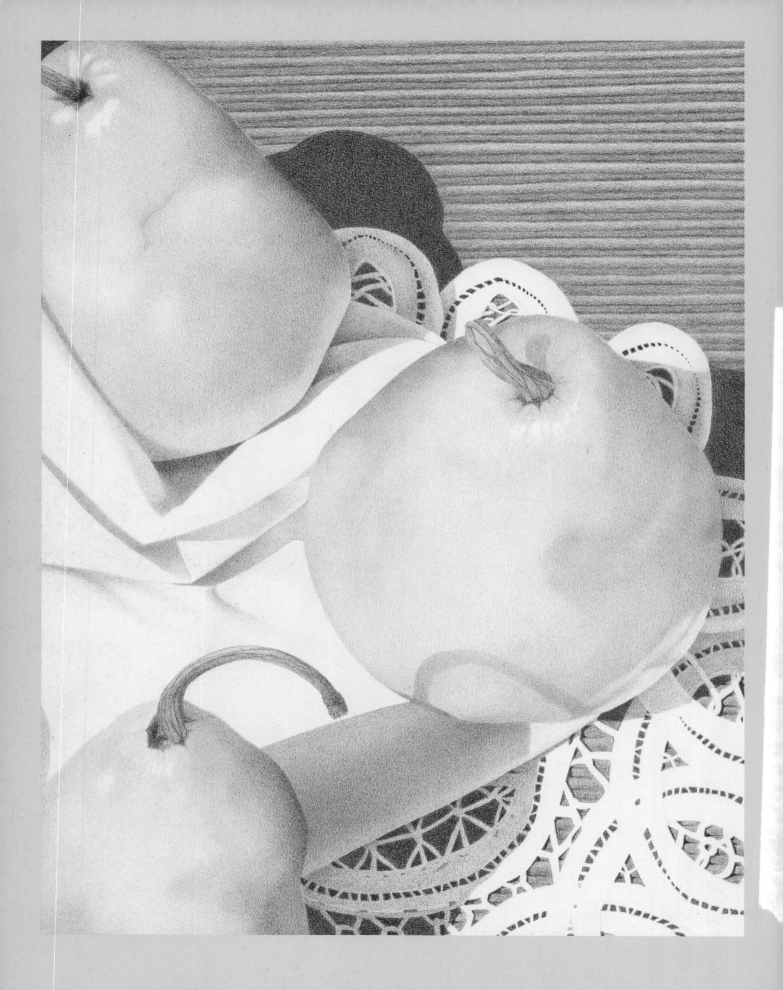

2
design your composition

This chapter gets right to the nitty-gritty of how to create well-designed artwork. It's all about how to organize your composition. *Composition. Design.* Scary words, but oh, so easy to implement—and what a difference they make in art. This chapter will help you no matter what medium you choose, because it's about planning, design savvy, ways of thinking, design rules and devices. It gives you the standards to apply to your work and provides you with the means of judging your own work and the work of others.

Sadly, many artists concentrate on technique and either ignore or have never learned the design basics. All the technique in the world won't make up for bad composition. Some artists have a natural sense of design, but they don't know how they can tell good design from bad—they just can. This chapter is for all of you who "do it" but don't know how or why, and for those of you who never consciously thought about design or had the opportunity to learn. It will give you the vocabulary to articulate your thoughts about composition, and it will give you the understanding of what good design is all about.

what are the elements of design?

Line—the handwriting of the artist.

Shape—the area within a closed line or edge. We recognize objects by their shapes.

Space—the area that gives the eye a rest. Space underscores and emphasizes active areas.

Texture—the way things feel. Texture lends a warmth and excitement to the work and activates surfaces.

Value/Contrast—the whole range of nuances from light to dark (value), and the difference between light and dark (contrast).

Color—enriches our world and our art. It is highly personal for each artist.

By your selection, use and manipulation of the elements of design, you begin the creative process. You express yourself. You arrange your composition. You strive for unity.

Unity can be translated as harmony, agreement, concurrence, completeness, oneness. It is what completes and finishes your creative work, giving it a sense of rightness.

PEARFECTION (DETAIL)
Janie Gildow
Colored pencil on Fabriano Uno HP 140-lb. (300gsm)
11½" × 16" (29cm × 41cm)
Collection of the artist

WHAT IS PROXIMITY?

what are the principles of design?

Composition consists of the orderly and purposeful arrangement of the design elements you choose. This order results from your knowledge and use of the design principles—the laws that govern the use of these elements: proximity, repetition, rhythm, continuation and balance. These principles work just as well with abstract art as they do with realism and with the enormous range of styles between the two.

Begin with the arrangement of shapes (positive areas). Shapes should be placed close enough to one another to indicate a relationship. Haphazard placement or too much space (negative areas) between shapes gives an unplanned appearance to a piece of art. By moving the shapes you have chosen into close proximity with one another, you not only create a relationship between those shapes, but at the same time, you activate the spaces around them, giving them an interest and identity of their own. As a rule, keep the important or positive shapes toward the center of your composition and the empty or negative areas more to the outside.

MAKING NEGATIVE SHAPES INTERESTING

In this composition, the proximity of the apples to one another and to the edges of the format breaks up the background and creates interesting negative areas.

UNRELATED SHAPES

These shapes are not related to one another in any way. They are different from one another, and they are too far away from each other to generate any kind of relationship.

MOVING SHAPES INTO RELATIONSHIP

Just by moving the shapes into proximity, or closer, they begin to relate to one another and take on more of a planned appearance. Now they form a group and do not look randomly placed. But the background is still just one big empty shape; this composition needs strengthening.

CLOSING IN

By closing in the edges of the composition (or format), and by rearranging and moving the shapes close enough to touch one another and the edges of the format, the arrangement of unrelated shapes becomes stronger. Now the background has been divided into separate areas, each with an interesting shape of its own.

WHAT IS REPETITION?

Repetition is the same thing happening over and over. Repetition can easily become boring, but when used with variety, it lends a strength and cohesiveness to your composition not possible with any other design device. Repetition is possible with all the elements (line, shape, space, texture/pattern, value/contrast and color). It is the *glue* that holds your composition together.

Rhythm

Rhythm is the result of repetition. Rhythm can be generated by any or all of the elements and can be varied to create interest. Repetition of lines, shapes, textures, darks and lights, and colors helps create relationships among the elements. The repetitions should be varied for interest and will lead the eye throughout the work by their similarity.

REPETITION WITHOUT VARIATION
The arrangement of these shapes is very organized because it has a structure or plan, but no variety or interest is generated by repeating the same thing over and over again.

VARIETY
Turning the checkerboard on an angle and varying the shapes to add interest and appeal makes the composition stronger.

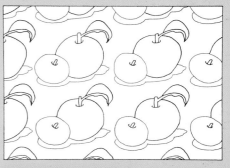

PREDICTABLE RHYTHM
The apples march across the page to an obvious and definite cadence. This rhythm is predictable and not particularly interesting. A design unit that repeats is called a *motif*.

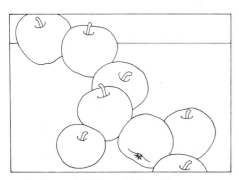

REPETITION WITH VARIATION
Apply varied repetition to your composition. Here, some apples are turned one way, some another. They all exhibit roundness, but none is exactly the same as any other. One has no stem, but it is turned, allowing the bottom to show.

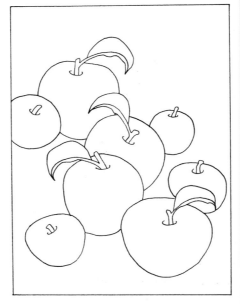

SUBTLE RHYTHM
The apple shapes repeat—but not exactly or predictably. Their repetition is subtle and more interesting. The leaves and stems have a quiet rhythm of their own.

SIZE VARIATIONS
Even the circle can be repeated with enough variation to keep it interesting.

WHAT IS CONTINUATION?

ACTUAL CONTINUATION
In the two shapes on the right, one black shape touches the other. Their outlines (or edges) connect and continue, one into the other.

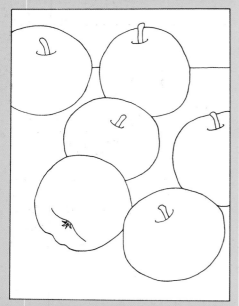

IMPLIED CONTINUATION
Here the implied continuation occurs in the background line we can't see (but know connects) behind the two apples. It also occurs in the apples that extend beyond the format. We complete the apple shape in our mind's eye.

Continuation is more subtle than the other principles, but it is just as important. *Actual continuation* occurs when two lines or edges meet, making an obvious connection the eye can follow. *Implied continuation* is a line or connection you cannot see, but that you know is there. Continuation is the *string* that holds your composition together.

Closure

Closure is another way of thinking about continuation. *Complete closure* occurs when an area is completely closed in—like a fence (with no gate) around a yard, or a complete circle. When used in a composition, it is a more obvious method of capturing the attention of the viewer. For example, when we see a shape like a rectangle or circle, we just naturally look inside it to see what's there. So a completely closed prominent shape makes a good main subject for your composition.

Partial closure is like the same fence around the same yard, but with several open gates. It occurs where one object or shape is overlapped or partially hidden by another or is cut off by the edges of the picture. We assume the complete closure even though we cannot see it—because we know it is there. Enough of the shape must show for us to be able to complete it in our mind's eye. If the shape is obscured to too great a degree, the effectiveness of the closure is lost. Partial closure is more subtle and therefore more interesting than the very obvious complete closure.

Don't use one to the exclusion of the other. If all your closures are complete, you will lose your composition due to a lack of proximity. If all your closures are partial, you may lose your center of interest and confuse the viewer. Just remember to keep closure in mind as you construct your composition.

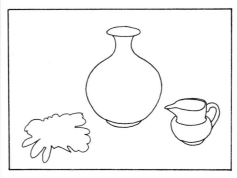

COMPLETE CLOSURE
In this illustration, every single shape is a complete closure: the flower outline; the vase, its foot and opening; the pitcher and all its parts, including the opening in the handle.

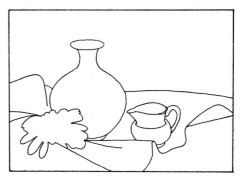

PARTIAL CLOSURE
The interest of the viewer is captured here in a more artful way, and the viewer is left to complete the connection. Partial closures include the vase body and foot, the bottom of the pitcher and its foot, and the fabric.

WHAT IS BALANCE?

As you plan your composition, be aware that all the design elements have visual weight: for example, a large shape looks heavier than a small one. Think of balance in terms of a seesaw, with shapes moving closer or further apart as needed to balance the composition.

In a symmetrical composition, one side is the mirror image of the other and already balanced. An asymmetrical composition must be thought of in terms of the visual weights of the elements contained in it and be balanced accordingly. Most artists prefer the asymmetrical composition for its variety and interest.

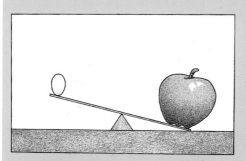

OUT OF BALANCE
The apple far outweighs the egg.

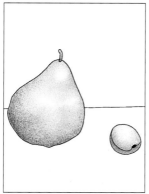

BALANCE BY COLOR TEMPERATURE
Small cool areas balance large warm areas.

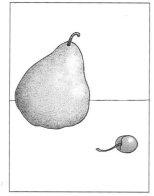

BALANCE BY COLOR INTENSITY
A small area of bright color balances a large area of less-intense (dull) color.

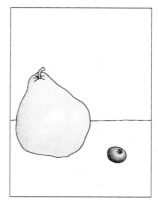

BALANCE BY VALUE
A small dark shape balances a large light one.

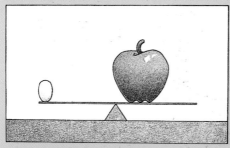

BRINGING INTO BALANCE
Moving the apple closer to the center (or fulcrum) brings it into balance with the egg.

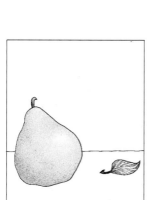

BALANCE BY TEXTURE OR PATTERN
Small areas of texture balance large plain areas.

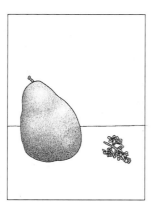

BALANCE BY SHAPE
Small areas of detail balance large plain shapes.

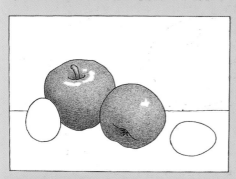

BALANCE BY SIZE
Keep the larger shapes of your composition closer to the inside of the composition and the smaller shapes more to the outside for balance.

HOW DO I DEVELOP A CENTER OF INTEREST?

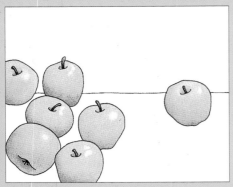

ISOLATION

You know how it feels to be left out of a group. You feel exposed and think that everyone is looking at you—which they just may be. It is the same with elements of your art. If they are isolated, they will be noticed first.

By your use of the elements, you can direct the viewer's attention to a specific area of your composition, so an important part of design is learning how to develop an area of emphasis: a focal point, a center of interest. The area of interest is set apart from the rest of the composition by differences.

Differences capture interest and attention. By incorporating some of the methods that follow, you can choose just where the viewer looks first. But don't use just one. Combine them as needed for impact.

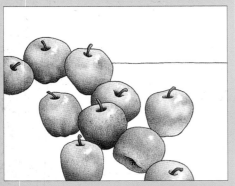

COLOR

One obviously different-colored apple generates the attention, becoming the center of interest.

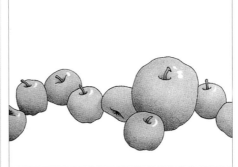

SIZE

Size differences catch attention. One large apple in a lineup of smaller ones becomes the focal point of the composition.

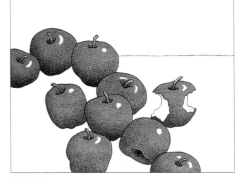

SHAPE

One partially eaten apple is different in shape from the round apples. You notice it first because it is different.

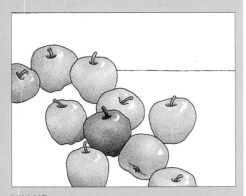

VALUE

Here, most of the apples are light, so the darker one is noticed. But it works the other way around, too. A light-colored apple in a crowd of darker ones would be the attention-getter.

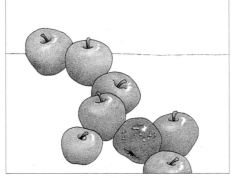

DETAIL

Any area of great detail invites the viewer to have a closer look. Use this device, but remember to include some areas of rest for the viewer. The detailed area will be underscored and enhanced by the plainer areas. Too much detail with no areas of rest can become confusing and tedious.

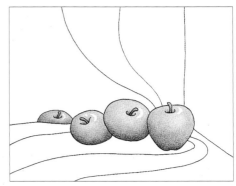

DIRECTIONAL DEVICES

Lines, slender pointed shapes, arrows, gradually diminishing sizes all point in a particular direction. Here, the room corner, the folds in the fabric and the gradually larger and larger apple shapes direct the eye and show us exactly where the center of interest is located.

Accents

Areas of minor importance or interest are called *accents*. These areas should not rival the focal point for attention, but should support and underscore it. They supply more interest to the piece and enrich the art. They should never be allowed to become as important and prominent as the focal point. You may have several accents—but you should have only one major center of interest.

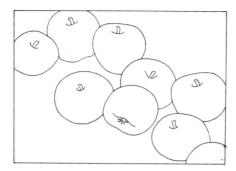

ACCENTS

The obvious center of interest is the apple with the bottom showing. This apple is seen in its entirety (complete closure), whereas all the others are overlapped and not completely shown (partial closure). The accents are the stems.

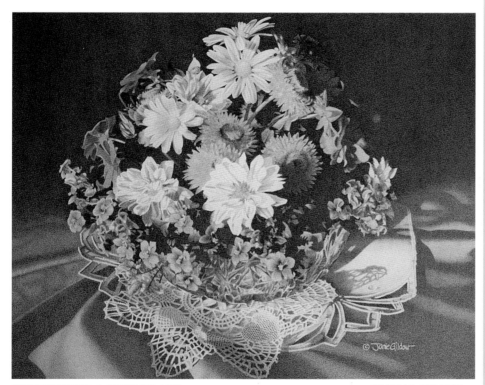

INTERPRETING A PIECE OF ART

The main focal point in this composition is the light pink flower. It becomes the center of interest because it is the area of greatest contrast—the lightest area against a field of darker values. The surrounding flowers are similar and contain as much detail, but their values are darker. Because of their secondary role, they are accents. The small violet flowers around the edge of the glass bowl make up another group of minor accents. Through their repetition, they generate a subtle rhythmic flow of both color and shape, which underscores and quietly complements the other elements in the work.

PARTIAL ECLIPSE
Janie Gildow
Colored pencil on Classic
 Rag Mat 100
13" × 16" (33cm × 41cm)
Private collection

HOW CAN I MAKE MY COMPOSITION DISTINCTIVE?

Cropping
When you crop, you cut off or remove some of the composition. Cropping usually gives the feeling of a closer, more intimate view. Don't be afraid to lop off a portion of an object. Remember that the mind's eye will complete partial shapes. Moving closer to your subject and cropping can strengthen your composition by making the negative areas more interesting.

Viewpoint
Where you are with relation to what you draw makes a big difference in whether you create ho-hum compositions or unique compositions with interest and pizzazz. Learn to look at your subject from different views and not just from straight on. It is the differences and the unexpected that give your work its interest and set it apart from the work of others.

CHOOSE A UNIQUE VIEWPOINT
The foreshortening of the figure and the unusual viewpoint make this subject more interesting than a side view.

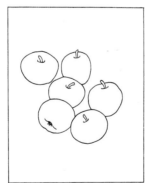

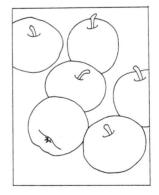

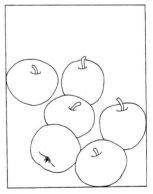

EMPTY SPACE
Too much empty space makes a weak composition.

CORRECT CROPPING
Cropping divides the background into several interesting areas and strengthens the composition.

Crop off a portion of the object, or move it so there is space between it and the edge of the format. Don't cut the object exactly in half.

INCORRECT CROPPING
Never allow the edge of an object to rest on the edge of the composition or format.

HOW DO I JUDGE A COMPOSITION?

Once you know the elements and principles of design, you are qualified to make a judgment on any piece of art.

Ask yourself these questions:

- Does this work catch my attention from across the room?
- Is there a good range of values—with strong contrast?
- Is the work interesting enough that it captures my attention for a time?
- Is it fresh and new, or too predictable?
- How has the artist used the six elements?
- Does the work show evidence of planning and forethought?
- Which of the principles of design are evident?
- Which of the other design devices did the artist use?
- Do the parts form one harmonious whole?
- Do the shapes relate to one another?
- Have both the negative and the positive shapes been made interesting?

- Do any of the elements repeat? Is the repetition varied?
- How are the colors arranged? Can I follow one color (or variations of it) throughout the composition?
- By what means does the artist lead me through the work?
- Does the composition feel balanced?
- Is there an obvious center of interest?
- Does the subject look too small for the format?
- Is the viewpoint unique in any way?
- Has the artist given me the opportunity to see the subject in a new way?
- Can I become absorbed in the work for a time?
- Has the artist given me something I can take away with me, keep, remember and treasure?

Remember, not every piece of art will (or should) exhibit *all* the principles of design—and some artists may break the rules for effect. But learn the rules first. Then you can break them.

HOW DO I JUDGE THIS COMPOSITION?

Value/Contrast — There is a good range of values in addition to strong contrast (rich dark shadows and areas of bright sunlight).

Interest — Many details make this piece interesting enough to capture the viewer's attention for a time.

Planning and Forethought — The composition exhibits a feeling of harmony and completeness.

Proximity — The main shapes are close enough to form a group.

Repetition — Colors and shapes repeat with variation.

Continuation and Direction — The principal shapes overlap and touch so that the eye is led throughout the composition by line, color and shape. Directional lines and edges continually bring the eye back to the center of the composition.

Balance — The heavier dark areas on the left are balanced by the visual weight of the darkened lower right-hand corner. The complexity of the flower helps to create a balance with the larger, plainer napkin.

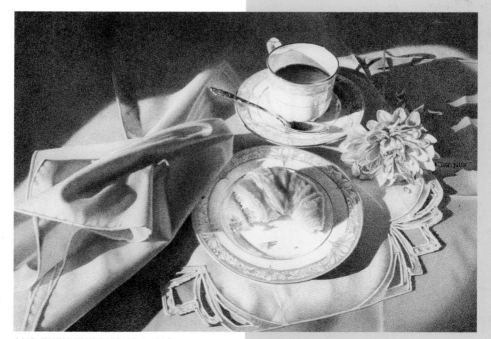

AND THEN THE PHONE RANG
Janie Gildow
Colored pencil on museum board
10" × 14" (25cm × 36cm)
Collection of Mr. and Mrs. John Hogue

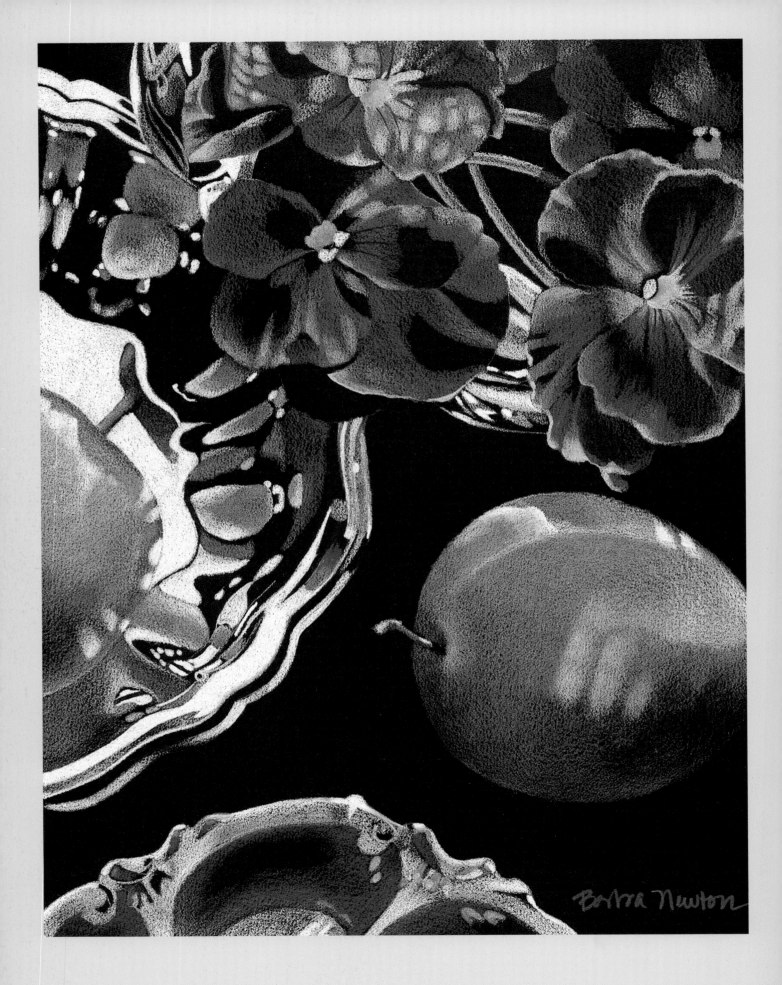

application *3* and technique

In this chapter we will show you fast and easy ways to get your ideas onto your paper. Once there, your choices of how to handle the colored pencil are many. One of the most appealing and exciting aspects of this medium is its versatility. Art created with colored pencil may be mistaken for a painting created with watercolor, a pastel painting, or a finely detailed color drawing. Each look is produced with the same pencils—it is the application and technique that varies. Colored pencil is fun! Play with your pencils. Soon you will discover your intuitive style. Because making art with colored pencil is not fast, the process is as important as the product. You must enjoy the laying down of color. Is your application of color bold and strong or soft and dreamlike? In this medium, there is a technique for both.

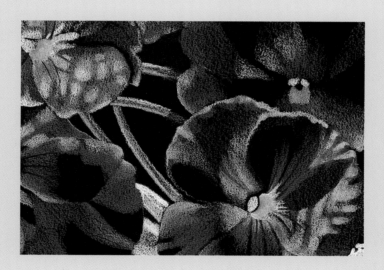

HAPPILY EVER AFTER #2 (DETAIL)
Barbara Benedetti Newton
Colored pencil on Strathmore black museum board
12⅛" × 10⅜" (31cm × 26cm)
Private collection

ONCE I CHOOSE MY SUBJECT, WHAT DO I DO?

You shouldn't just jump in and start coloring on your good paper. Instead, some planning in the beginning will save you a lot of time overall. To prevent mistakes and erasing, try to solve as many problems as possible before you begin your final painting.

THUMBNAIL VALUE SKETCH

A thumbnail sketch is a very small (approximately 2" × 2" [5cm × 5cm], hence the name), loose, freehand drawing on white paper using a graphite pencil or a pen that marks dark enough to represent black or the darkest value in your planned work. Fill in the middle values using less pressure. Leave the white of the paper as your lightest value. The purpose of completing thumbnails is to get a clear idea of the composition and values of your planned artwork before you launch into color. This value-sketch process is simplified if you work from reference photos or from life rather than working from your imagination, because you can see the values as they appear before you.

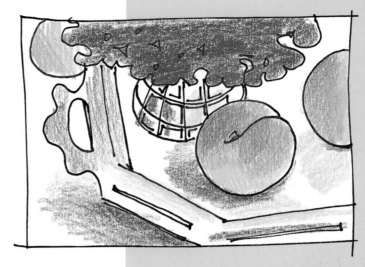

THUMBNAIL COLOR STUDY

A color study is useful to develop a color scheme that helps convey the message of your finished artwork. Create a line drawing, in graphite or black ink, of the composition you chose from your thumbnail sketches. Use a copier to make several thumbnail-size copies of the drawing. With colored pencils, color the thumbnails using a different palette for each. Remember that warm colors advance and cool colors recede. Consider the value and intensity of colors.

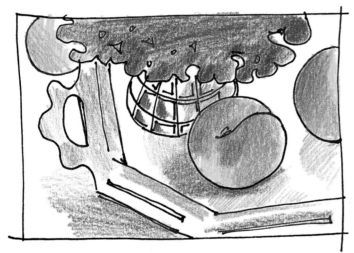

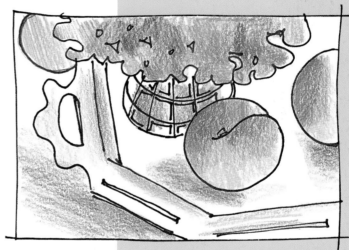

PRELIMINARY SKETCH

Once you've done your thumbnails, it's time to draw your subject. Keep the shapes simple at first (above left). Lightly sketch in the objects as geometric or basic shapes until you are sure the size and proportion are correct. Next, refine the lines and add detail (above right). Totally completing one object or one part of the composition only to discover that it is the wrong size or proportion is not only disappointing, but very time-consuming, as you must erase and redraw.

HOW DO I TRANSFER MY SKETCH TO MY DRAWING SURFACE?

ILLUMINATION TRANSFER

DIRECT TRANSFER

GRAPHITE APPLIED TO SKETCH

Transfer methods for getting your preliminary sketch to your final drawing surface vary. The method you choose will be affected by the thickness of your drawing surface and by whether it is white or colored.

Illumination Transfer

If you work on white 3-ply or thinner paper and can see light through your paper, you can transfer by the illumination method. To transfer your preliminary sketch onto drawing paper, secure the sketch to a light-box (purchased or handmade) or clear glass window pane (sliding glass doors work well because you can stand right next to them). Place your final drawing paper on top of the sketch and secure with tape or mounting putty. With the tool of your choice (graphite, erasable colored pencil, wax- or oil-based colored pencil), lightly trace over the lines of your preliminary sketch onto your drawing paper. Always use a light touch to avoid impressed lines.

Direct Transfer

If your preliminary sketch was completed in soft graphite on tracing paper, you can place it facedown on your white or light-colored drawing surface. Tape securely along one edge. If you have a light touch, a variety of pens, pencils or pointed objects can be used to carefully follow along on top of each sketch line. With little pressure, the graphite of your sketch will be transferred to your drawing paper (lift your sketch from time to time to check). If you have a heavier touch, use a soft, bright colored pencil for the transfer. That way you won't have impressed lines to worry about and you can easily see which lines have been traced over. Remember one thing with the direct transfer method: Your final drawing will be reversed from your sketch.

Graphite Applied to Sketch

If your preliminary sketch is on tracing paper, you can also make use of this method:

Place your tracing paper sketch facedown on a table and apply a dense layer of graphite on the back side on top of each of the sketch lines. Brush excess graphite off and turn the sketch right side up. Place it on top of a clean, blank white or light-colored drawing board or paper and secure along one edge with removable tape. Redraw each sketch line lightly as described at left, in the direct transfer method. Lift the sketch occasionally to check that your transfer lines are dark enough to see but not so dark that they will interfere with the application of colored pencil. If the lines are too dark, lift excess graphite by dabbing with mounting putty or a kneaded eraser. To prevent smudging, you may want to place a slip sheet between the graphite- backed sketch and your good drawing paper beneath where your hand rests.

Transfer Paper

You can purchase transfer paper rolls or sheets at your art supply store. You can also make your own graphite transfer paper by covering one side of a sheet of tracing vellum with graphite from a soft lead pencil, such as Faber-Castell Ebony. Polish with a tissue and reapply (polishing smooths out the graphite and presses the loose powder into the vellum). To keep handmade transfer paper from tearing during repeated use, tape the edges with masking tape.

To make transfer paper for transferring onto a dark working surface, coat the back of vellum (or the back of your sketch along the lines you want to transfer) with white or light-colored pastel stick. Rub the pastel with your fingers or tissue and tap the excess into a wastebasket. Once your transfer paper is ready for use, place it graphite side down onto your drawing surface. Then place your sketch on top, and trace its lines onto the drawing surface. Use a slip sheet under your hand between the graphite and your good drawing surface. If you don't, the graphite will create smudges on the good paper from the weight of your hand.

The Grid Transfer Method

Another way to transfer your preliminary sketch to your drawing paper is to first outline the boundaries of your sketch and measure height and width. Place a piece of clear acetate or tracing paper over your preliminary sketch and with a pen or pencil trace the boundary outlines. On the tracing paper, divide the sketch area into equal subdivisions or squares. If your sketch is quite a bit smaller than you plan to make the final drawing, the squares of your grid will need to be smaller than if the sketch is the same size or larger than the final drawing. Now draw a second grid the size of your final drawing with the same number of squares lightly in graphite on the final working surface. With a light application of graphite, transfer the information free-hand from each square of the sketch to the corresponding square on the final drawing surface.

Projectors

These tools eliminate the need for a transfer medium or the grid method. Using light, they project a sketch, photo or slide image (depending on the type of projector you use) onto the wall or table where your drawing paper or board is positioned. Use a graphite or colored pencil to reproduce the projected image in outline form onto your working surface.

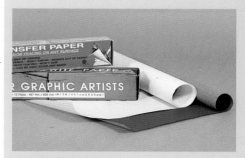

TRANSFER PAPER
Saral transfer paper is wax-free, available in graphite, white or colored, and you can use the same sheet several times. Since it is wax-free it erases or lifts as easily as graphite pencil. Use white or light colors of transfer paper for work on colored surfaces.

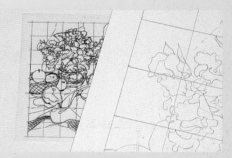

GRID TRANSFER METHOD

TRANSFERRING FROM A PHOTO
If you have a reference photo that is the same composition as the art you plan to create from it, the photograph takes the place of the preliminary sketch. Cover your photo with clear acetate and proceed to draw a grid as done in the grid method of transfer.

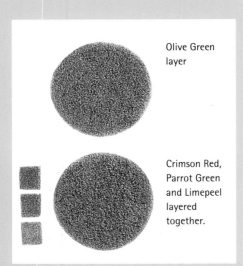

Olive Green layer

Crimson Red, Parrot Green and Limepeel layered together.

BUILD INTEREST
Interesting texture and color come about by layering colors in a random pattern.

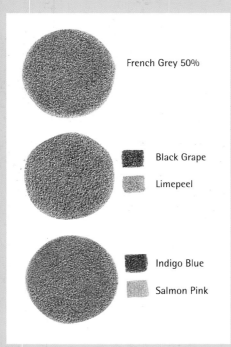

French Grey 50%

Black Grape

Limepeel

Indigo Blue

Salmon Pink

GRAY CAN BE BEAUTIFUL
Beautiful grays are made by layering complementary colors.

Layering

The color put down by colored pencils is translucent, much like watercolors, and like watercolor, using only one color gives a simplistic coloring-book effect. To create interesting hues, use colored pencils to their full potential by layering two or more colors on top of one another. This is the process of building a new color from the bottom up. The mixture of color you end up with depends on how evenly and heavily you apply each layer of color, and in what order. As you become more skilled you may find you can reach the desired hue in fewer layers than previously.

Colors may be mixed precisely in even, consistent layers, or for added interest, try letting the color on the bottom peek through the top layer in a random pattern.

ONE-COLOR LAYERS
In this drawing, one green, one red and one pink were used, but not mixed together. Colors were applied with attention to value for a given area, but regardless of how many layers of green are applied, it will never get darker than its original value. Without added value, the leaves and stems look flat.

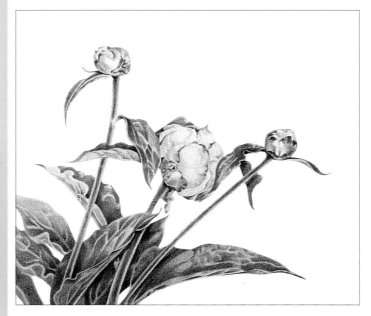

MULTICOLOR LAYERS
This drawing was created by layering two or more colors on top of each other to build interesting color as well as improved values.

HOW DO I APPLY THE PENCIL EVENLY?

Even application of pencil depends on the surface to which you are applying the pencil, the sharpness of the pencil point, the pencil pressure on the drawing, and the stroke.

Differences in Paper Tooth

Each paper has a texture or tooth that, under magnification, resembles mountains and valleys. Smooth paper has low hills and shallow valleys—resulting in less texture. Rough paper has higher hills and deeper valleys—greater changes in contour equal more texture. A paper with lots of tooth gives a rough, textured, spontaneous appearance to your color application. A slick paper with little tooth takes fewer layers of color since the valleys that hold the color are shallow.

Strokes

The way you apply pencil helps to identify your work and set it apart from the work of others. A smooth, even application is important for realism. A more vigorous or spontaneous application works for more expressive art. For an even application of tone, a circular or linear stroke may be used. The stroke should not be identifiable in the finished drawing.

PENCIL POINT AND PRESSURE

If your pencil point is dull, it will be too big to get down into the valleys and will apply color only to the mountaintops even if you exert added pressure. If you are trying to apply color evenly and the white of the paper keeps showing through, sharpen your pencil. A sharp point can reach down the sides of the mountain for a fine texture or coating of color.

Smooth (hot-press) paper

Rough (cold-press) paper

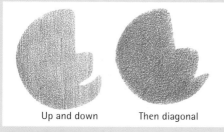

Up and down Then diagonal

LINEAR STROKE

If you use a linear stroke to create even tone, the strokes must be close together and applied with light pressure using a sharp tip. As the second layer of the same or a different color is laid down, unite the strokes of color by turning your paper and approaching the application from a different angle.

STROKE OVERLAP

With the linear stroke technique, if you do not turn your paper, but rather make all strokes in the same direction, you will develop bands of heavier color concentration where your strokes overlap.

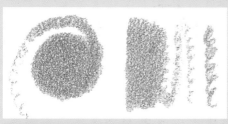

CIRCULAR OR OVAL STROKE

By making a series of small overlapping circles or ovals, you can avoid any uneven overlap. Filling in tooth is easier and application is smoother when you use the circular or oval strokes. As you work, don't try to adhere to exact, precise lines or rows. Take into account the shape of the area you wish to cover and fill accordingly.

HOW CAN I MAKE GRADUAL CHANGES IN VALUE AND COLOR?

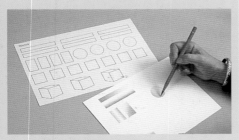

PRACTICE SHAPES
Draw a series of shapes on your favorite surface and use them for practicing smooth, even application and gradual changes in color and value.

Blending Value

Achieving the value you want depends on which pencil you use and how much pressure you apply. Each colored pencil was created with a specific value (the lightness or darkness of a color). The pigment of a red pencil is much darker in value than the pigment of a yellow pencil. When any color is applied full-value, either by heavy pressure or many light layers, it is as dark in value as it can be by itself. By applying fewer layers of the color or a lighter application, it can appear lighter in value by the white of the paper showing through the strokes of color.

When applying color, periodically lean back, squint or blur your vision to see how evenly the value is changing. Using a val-uefinder is a good way to check your application. Work back into any area with a sharp tip to cover the tooth evenly. As you work, your pencil tip will wear down. As it does, rotate the pencil to keep an edge against the paper. The completed value change should be both even and gradual. There should be no uneven spots or areas (too dark or too light).

Blending Color

To make gradual changes in color, carefully layer a new color over the base color by overlapping a portion and gradually lightening pressure.

ONE-COLOR VALUE CHANGE
To make an evenly graded value change, apply color smoothly and uniformly using medium pressure. This is your dark value. Gradually lighten pencil pressure toward the lighter value. Move your grip on the pencil farther from the point for a really delicate (light value) and even coverage. Balance the pencil in your hand to let the weight of the pencil make the mark on the paper. Keep a sharp tip on your pencil for even coverage.

TWO-COLOR VALUE CHANGE
When blending one color into another color, begin by making an evenly graded value change from the darker value toward the lighter with the first color as described above. Then do the same thing with the second color, but *begin from the second color* and work *back into the first color*. Gradually and evenly lighten pencil pressure into and toward the darker value of the first color.

HOW DO I MAKE THE COLOR LOOK REALLY SMOOTH?

Burnishing

You can make a color really smooth by burnishing it. Burnishing is done by applying medium to heavy pressure with a white or light-colored pencil over a darker color. This process produces a glaze that unites the pigment and forces it down into the tooth of the paper. Once the pockets or valleys of the tooth of the paper are filled with color, you have a smooth base of pigment with no paper texture showing. The lack of visible paper texture is what makes colored pencil look smooth or paintlike.

Colorless Blender Pencil

Using a colorless blender pencil is another way to get smooth results. Two such pencils are Lyra Rembrandt Splender and Prismacolor Colorless Blender. These products blend the colored pigment together, obliterating the texture of the paper, without the white glaze produced by burnishing with a white or light-colored pencil.

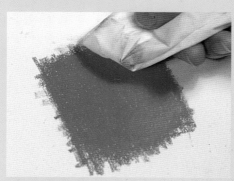

POLISHING COLOR

To remove stroke marks and give your color a smooth finish, gently polish color with a tissue or soft cloth. There is an abundance of pigment in a burnished area, so don't be alarmed if a small amount of color comes off on your tissue.

Prismacolor White (wax-based) Polychromos White (oil-based) Lyra Rembrandt-Splender (oil-based) Prismacolor Colorless Blender (wax-based)

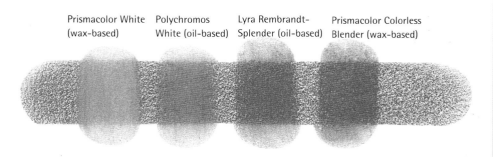

These samples show the varied results of using different types of burnishing and blending tools.

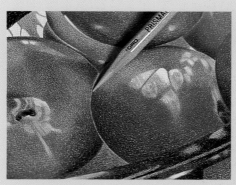

The colorless blender can also be used to crisp up ragged edges.

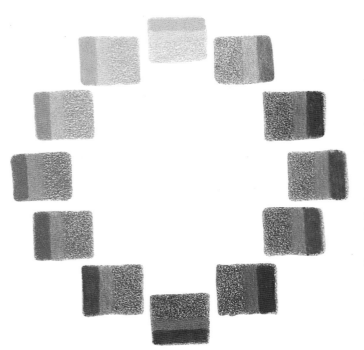

BURNISHING WITH WHITE

When burnishing more than one color, wipe color residue off the tip of your white pencil to avoid transferring color. After burnishing, you may want to reapply the original color for a bright, paintlike look.

In this color wheel, the burnished color shows in the center of the swatch and the reapplied color is smooth and intense.

CAN I LIQUEFY THE PIGMENT OF "DRY" COLORED PENCILS?

Additional color can be applied dry over a subtle background for texture or dissolved again.

With a cloth you can achieve a broad sweeping movement of color. The more pencil you put on the paper, the more color you will have to move around.

An electric or battery-powered eraser erases color more completely from the dissolved area.

White pencil or a battery-powered eraser can be used for detail.

Dry white colored pencil shows up surprisingly well when applied over other colors that have been dissolved—in this case, red and yellow.

Black colored pencil. The darker area to the left has been dissolved with brush and solvent.

Enriched black. Indigo Blue and Tuscan Red have been applied on top of Black pencil. Notice how much richer the color is, especially in the dissolved area on the left.

Traditional colored pencil application is known to be time-consuming. But you can create lush (or subtle) colors and cover large (or small) areas rapidly by dissolving wax- or oil-based colored pencils with solvent. Be prepared to work quickly before the solvent evaporates and dries. Liquefy "dry" pencils with odorless turpentine or rubber cement thinner. Always heed the warnings from the manufacturer: Use good ventilation and wear latex gloves. Be aware that solvents will alter the color of the pencil and can buckle your paper, so select a board or paper that tolerates moisture.

Pour a small amount of solvent into a narrow-necked container with a lid and keep the container closed when possible to avoid breathing fumes and to prevent the evaporation of the solvent. Manipulate the liquefied color with paintbrushes, cotton swabs, white cotton rags or tortillons (tor tee yong) dipped in solvent.

demonstration | liquefy pigment

1 FIRST LAYER
Apply Black pencil without regard to evenness, because once solvent is applied, the original strokes of color will dissolve and can't be distinguished.

2 SECOND LAYER
Apply Indigo Blue on top of the Black pencil in the same manner.

3 DISSOLVE PIGMENT
With a small brush and solvent, carefully liquefy and spread the color within each of the sections or holes of the lace. Color will be dense and full, and the paper texture will be filled with color and not discernible.

CAN I ESTABLISH A TONAL FOUNDATION BEFORE ADDING COLOR?

In the process of creating art with colored pencil, you'll have numerous decisions to make. Two of these decisions are about value and color intensity. They are very separate but also absolutely linked together. Value is the lightness or darkness that gives objects the form and volume that helps us identify what the object is. Color intensity is the brightness or dullness of a color. It may be helpful to establish the values in a drawing before adding the color so both decisions don't have to be made simultaneously. A tonal foundation establishes value. It is usually created with black, gray, sepia or any color of low intensity. This technique is referred to as *grisaille* (greese eye).

materials list

Surface
Strathmore 500 Bristol Plate

Pencils
French Grey 90%
Indigo Blue
Tuscan Red
Pink
Limepeel
True Blue

demonstration | grisaille

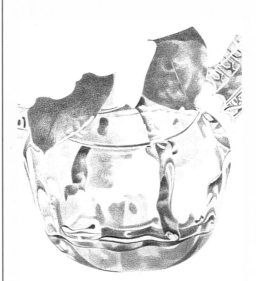

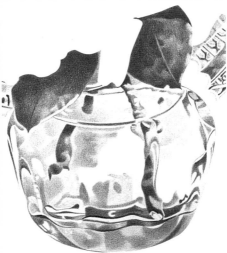

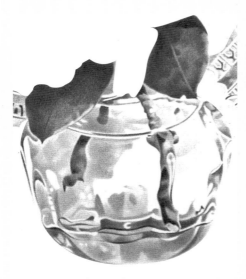

1 BASE LAYER
Establish tonal foundation for your drawing with French Grey 90%.

2 ADD COLOR
Layer Indigo Blue on top of your foundation.

3 DEVELOP COLOR
Use Tuscan Red to enrich the dark areas. Apply Pink, Limepeel and True Blue in selected areas for interest.

HOW DO I KEEP COLORS BRIGHT ON A BLACK GROUND?

Canary Yellow

Light Ochre (PC)

Spanish Orange

Crimson Red

Carmine Red

Mahogany Red

Dark Purple

Parma Violet

Violet

Ultramarine

Indigo Blue

Dark Green

Marine Green

Yellow Chartreuse

Chartreuse

Bronze

Tuscan Red

Black Grape

COLOR DIFFERENCES
Look at the differences between colors that have been layered over heavy white pencil, colored directly on black, layered over a medium layer of white pencil, and applied directly to white paper.

Reverse Grisaille
Colored pencil looks rich and sumptuous on black paper, but some colors stand out more than others. This is because some colors are more opaque than others.

When working on a dark ground you must use a white (or light-colored) pencil on the dark paper to establish the light values and white before adding color. Think of it as "reverse grisaille."

Where you want values to be very dark, don't apply a light or opaque foundation, merely layer color directly onto the black.

materials list

Surface	Scarlet Lake
Black Letramax	Tuscan Red
	Dark Purple
Pencils	Cinnamon (PC)
White	Dark Brown
Deco Yellow	Bistre (PC)
Spanish Orange	Slate Grey
Carmine Red	
Black Grape	**Other**
Indian Red (PC)	White Saral trans-
Indigo Blue	fer paper
Crimson Red	

demonstration | cherries on a dark background

1 TRANSFER THE SKETCH
Use white transfer paper to transfer your sketch to the black surface. Then use a kneaded eraser or piece of reusable adhesive to remove most of the white and make the white lines very faint. This keeps them from showing through your work and from affecting the dark colors you will use.

2 WHITE FOUNDATION
Lay in values with the White pencil. Increase pressure in the lightest areas and gradually and smoothly decrease pressure toward the dark areas. Don't make everything white. Leave some areas black.

3 ADD THE LOCAL COLOR

The Yellow and Red Cherry—Color what will become the yellow area on the bottom left cherry, using Deco Yellow to cover the white, giving it some yellow color as a base for the Spanish Orange. Then layer Spanish Orange over the Deco Yellow to warm the area.

Use Carmine Red to color the rest of that cherry, applying less color in the shadow cast by the bottom right cherry.

The Red Cherry—Use Carmine Red to color the lightest half of the bottom right cherry. Increase pressure right around the white highlight. Gradually lighten pressure toward the dark side of the cherry to let more of the black paper show. Then color the darkest edge of the cherry with Black Grape.

Gradually work the dark color into the Carmine Red, lightening pressure toward the lighter half of the cherry. Stop about halfway. The two colors should gradually blend together at the halfway point. Light gradually changing to dark is what makes the cherry look three-dimensional.

The Dark Cherry—Use Indian Red and Indigo Blue on the top cherry in the same manner to create depth. The lighter part of the cherry near the highlight should be colored with the Indian Red. Then, using light pressure, color toward the outside of the cherry, but don't color clear to the edge. Use Indigo Blue to color the darker edge and gradually lighten your application as you approach the area around the highlight.

4 COMPLETE THE CHERRIES

The Yellow and Red Cherry—Complete this cherry with Crimson Red. Blend the Crimson Red into the yellow area and use it to color the darker half of the cherry. Use it lightly in the shadow cast by the other cherry. Don't totally cover the Carmine Red around the white highlight.

The Red Cherry—Cover the Carmine Red with Scarlet Lake, reducing pressure and gradually blending into the Black Grape. Then cover the Black Grape with Tuscan Red, again gradually blending back toward the lighter half of the cherry.

The Dark Cherry—Use Scarlet Lake to color immediately around the white highlight. Then layer Dark Purple over the rest of the cherry. Where the two meet, gradually blend them together.

The Stems—Begin to establish the light edges of the stems with Cinnamon. Keep a sharp point for making clean edges.

5 FINISHING TOUCHES

The Stems—Outline the darkest side of each stem with Dark Brown. Then use Bistre as the middle tone, blending it into the Dark Brown and Cinnamon.

Shadows and Background—To utilize your black surface and let it work for you, leave all cast shadows black. Lightly color the rest of the background with Slate Grey and the dark shadows will pop out.

To create the fine white lines representing hairlike filaments on tomato vines with sgraffito technique, first complete the area with local color (the heavier the better).

Whiskers on cats, veins in leaves, strands of hair in the sunlight, fine light lines on a dark ground—these are prime candidates for *sgraffito* or *impressed line* techniques. Both methods are effective ways of making a fine white or light-colored line of detail.

Sgraffito

Sgraffito (zgra FEE toe) is done after color is applied. It is accomplished by use of an art knife or similar sharp object. It works best if there is a heavy application of medium- to dark-value colored pencil applied to fairly hard (not soft) paper. Start with a light stroking motion of the blade so as not to damage the paper. As you scrape the colored pencil away, the color of the paper will show through but may be slightly altered because some of the color binds to the paper. To help keep paper white, apply colorless blender under the first coat of color in areas planned for sgraffito.

Impressed Line

Impressed line is a technique that is implemented before you add color. It is a ditch or dent in your paper so small that the point of your pencil doesn't go down into it. Therefore, it remains the color of the drawing surface.

But you can also impress lines in color using the same technique. Just put down your base color first, then follow the steps to impress your lines.

AN ABUNDANCE OF PIGMENT IS NEEDED

The difference between dense color and the white paper after pigment removal makes fine lines most apparent.

TOMATOES
Barbara Benedetti Newton
Colored pencil on Rising Stonehenge paper
15¼" × 15" (39cm × 38cm)
Private collection

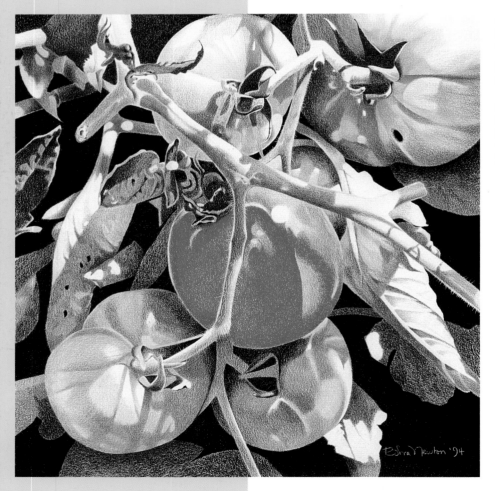

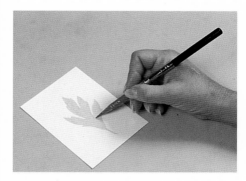

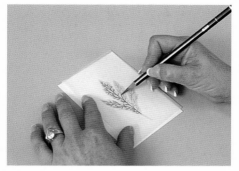

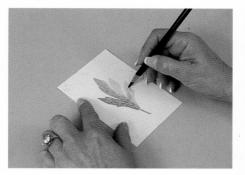

1 APPLY COLOR

Draw and color in the base of your leaf.

2 IMPRESS THE VEINS

Position a sheet of tracing paper where you want the veins of the leaf to go, and lightly draw in veins. Then use a 2H (or harder) lead pencil or similar tool and go over the veins, making an impression in your drawing paper.

3 APPLY MORE COLOR

Remove the tracing paper and apply additional color to your leaf, going over (but not down into) the veins. The veins will appear as your lighter base leaf color.

demonstration | **coloring over impressed lines**

1 DRAW THE VEINS

After drawing the outline of a leaf, place a piece of tracing paper over the sketch and lightly draw the veins where they will appear later. Don't use much pressure, draw very lightly.

2 IMPRESS THE VEINS

Position the tracing paper where you want the veins to go on the leaf. Use a 2H (or harder) lead pencil or similar tool and redraw over all the vein lines; press down hard enough to make an impression in the drawing paper beneath but not hard enough to break through the tracing paper.

3 APPLY LOCAL COLOR

Remove the tracing paper. Using a colored pencil with a slightly flattened tip, carefully color over the leaf shape. The veins will show as white lines. Be careful not to color down into the impressed lines.

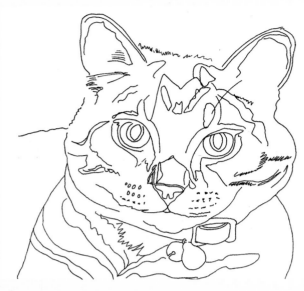

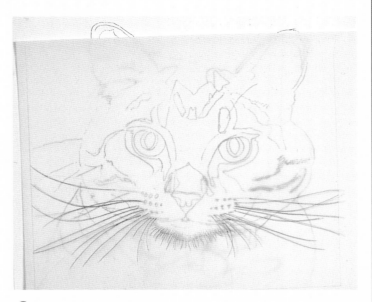

1 COMPLETE THE SKETCH

Draw this cat on your paper, minus the whiskers.

2 IMPRESS THE WHISKERS

Position a sheet of tracing paper over the cat where you want the whiskers to be and lightly draw them in. Then use a 2H (or harder) lead pencil or similar tool and go over the whiskers, making an impression in your drawing paper.

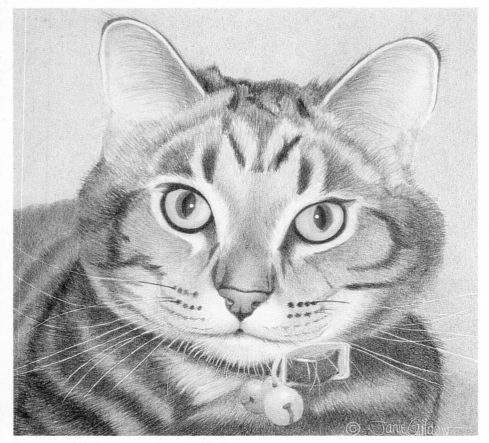

3 APPLY LOCAL COLOR

Color in your cat, being careful not to color down into the whiskers. The whiskers will show as white lines.

BUZZBEE
Janie Gildow
Colored pencil on Fabriano Uno HP 140-lb. (300gsm)
7" × 7½" (18cm × 19cm)
Collection of the artist

CAN I REMOVE A SLIGHT AMOUNT OF COLOR?

The most effective way to remove or lift a slight amount of unwanted color from an area is to apply reusable adhesive with a dabbing motion. This product lifts color more efficiently than a kneaded eraser. It is also a great way to create texture and interest and soften edges. Brands vary from gentle to quite aggressive. Experiment on an uncolored paper surface—the more aggressive the adhesive, the louder the *pop* sound as it releases from the surface. You may want to keep a couple brands on hand for varying degrees of removal.

REUSABLE ADHESIVE
To softly lift a small area of pigment, dab color with reusable adhesive.

FRISK FILM
To remove color more precisely you may prefer to use Scotch Magic tape or Frisk Film. Apply the tape or film to the area needing adjustment. Lift a small area of color by rubbing a ballpoint pen or other similar object on the exact spot to be lifted.

CREATE TEXTURE BY LIFTING COLOR
To create soft flour on the hands in *Making Ravioli*, the area was first completed with local skin colors. Then, the color was gently lifted off with masking tape. (Warmth from your hand softens the colored pencil, causing it to adhere to the masking tape as it is removed.)

For scratches in the rolling pin, masking tape was applied over the color, then scratched with a fingernail and removed, leaving a white scratch.

The flour on the table was created by coloring the table around the flour, leaving the white paper to read as white flour. No colored pencil was applied to the dough on the rolling pin.

MAKING RAVIOLI
Barbara Benedetti Newton
Colored pencil on Rising museum board 2-ply
12½" × 12¾" (32cm × 32cm)
Collection of the artist

ARE THERE TECHNIQUES THAT EXCITE THE EYE?

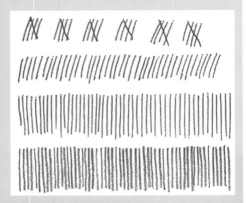

VERTICAL-LINE ROWS

Practice vertical-line technique with a ballpoint pen and your favorite drawing surface, tallying in groups of five across the paper.

Then tally another row without the diagonal strokes and without the space between the groups. The marks should be vertical, not slanted, and should begin at the top and end at the bottom abruptly—no gradation of color or change in the width of the stroke.

Make another row of strokes closer together—about 1/16" (2mm) apart.

Then, try the same thing with a sharp colored pencil. Turn your pencil after every few strokes to keep a fine line, and sharpen often.

VERTICAL-LINE CIRCLES

Make circular areas of mixed color with randomly placed vertical strokes. When yellow is one of the colors in your mixture, apply that layer first so it can peek through the other colors. For this exercise, apply red next, then blue. Random color and texture are part of the charm of this technique. A shingle effect (far right) is created when strokes are applied in rows.

A.J. BENEDETTI, SR.
Barbara Benedetti Newton
Colored pencil on Rising Stonehenge paper
19¾" × 13¾" (50cm × 35cm)
Collection of Bettina Benedetti Waddle

We have talked about how to create consistent, evenly applied passages of color, but what about a technique that is, in itself, more interesting and exciting to the eye?

Vertical-Line Technique

Vertical-line technique is created with parallel lines usually about ½" (1cm) in height, evenly spaced from one another. For those to whom this technique comes naturally, it can be a time-saver in the application of color. Practice to establish your stroke for this technique.

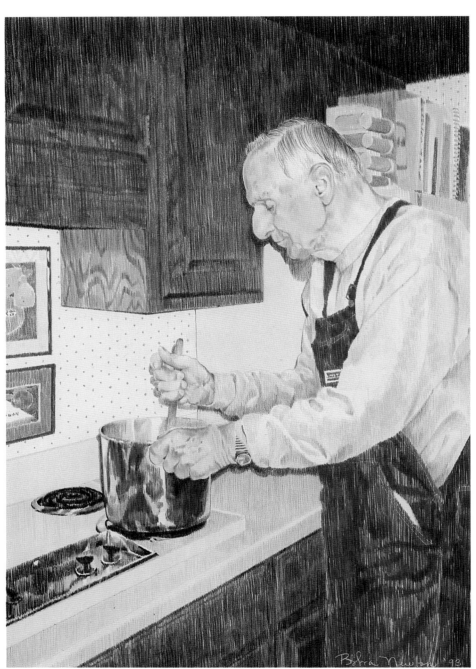

Look how wonderful a whole painting done in vertical-line techniques can be.

Juxtaposing Color

Though colored pencil is a translucent medium with all the joys of building color layer upon layer, there are other methods of applying color. One manner is to place one color next to another color rather than directly on top of it. This side-by-side placement is called *juxtaposing color*. When one color is placed adjacent to another, the viewer's eye does the mixing rather than the artist. But before the mind's eye unites the colors, there is an excitement about the way two or more colors play against each other.

Colors of the same family bordering each other produce a slight undulating effect while complementary colors or colors of extreme difference in contrast or temperature appear to recede and advance, making the color bounce.

Open Crosshatch

This technique produces a carefree, animated approach to a subject. Your strokes may be curved or straight, crosshatched or left open-ended. Though you can take liberties with volume and form, letting the dynamic stroke dominate the scene, this technique isn't as random and unplanned as it appears at first glance. Colors are mixed both one on another as in the traditional layering and at the same time play against one another as in vertical line and juxtaposition of color. Yellows that are placed on the paper first may show or peek through subsequent strokes. Likewise, after a number of layers of strokes are applied creating value, white or light colors can be crosshatched over the top for effect.

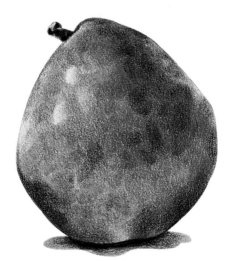

JUXTAPOSING COLOR
Place colors next to, as well as on top of, each other.

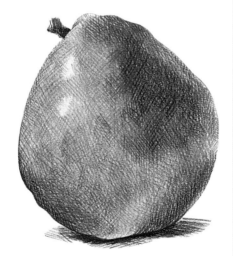

OPEN CROSSHATCH
This technique gives the appearance of spontaneity but is actually quite controlled in the application of strokes.

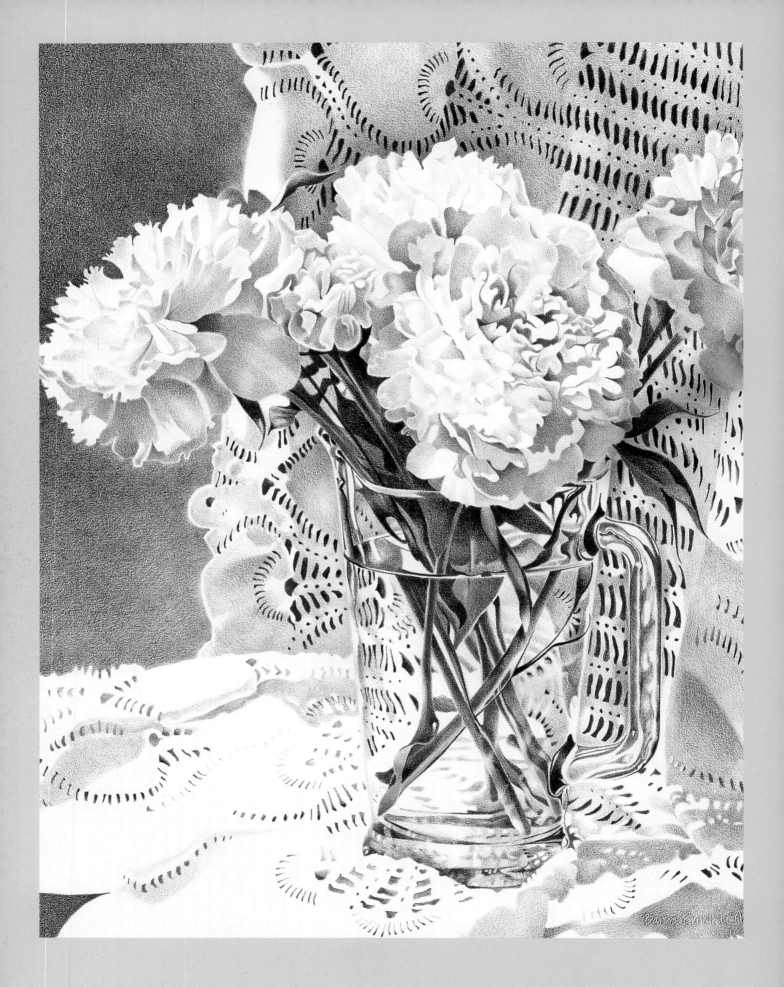

color and light solutions

Don't be afraid of color. Make it work for you by becoming familiar with the color wheel. Learn how the color wheel works, how colors relate to and affect one another and what to expect when you mix colors. Learn all about color value and color intensity.

Get acquainted with the colors of your pencils as you make the color fan and the complement wheel. Create colors you never mixed before. Enjoy color. Fill your life (and your art) with it.

Light alters the value of colors. A good range of values makes our art more interesting and realistic objects more recognizable. Light, shadow and contrast are elements that go hand in hand with good color choices to make successful art.

BLESSED EVENT (DETAIL)
Barbara Benedetti Newton
Colored pencil on Rising white museum board
22" × 23" (56cm × 58cm)
Collection of the artist

When curved into a circle and attached end to end, the spectrum becomes our color wheel.

This circular form of viewing color is attributed to Sir Isaac Newton. Arranging the visible colors in a circle or wheel makes it easy to see each hue (pure color) in relationship with all the others. The color wheel represents pure, undiluted hues and is arranged by value. Yellow, the lightest color, is placed at the top. Violet, the darkest color, is located at the bottom.

Primary Colors
The primary colors are red, yellow and blue. They cannot be made by mixing one color with another color. They are located equidistantly from one another on the color wheel.

Secondary Colors
The secondary colors are made by mixing nearly equal amounts of one primary with another primary. For example, mixing yellow with red produces orange. Each secondary color is located halfway between the two primary colors used to mix it.

Tertiary Colors
Mixing a primary color with a secondary color produces a tertiary (TERSH ee ary) color. Each tertiary has a compound name made of the two colors from which it was mixed. The primary color is always listed first. For example, red mixed with orange makes red-orange. Each tertiary is located between its primary and secondary.

Black, White and Gray
Black, white and the cool grays created as mixtures of black and white are called *achromatics*. They contain no color. When mixed with the pure colors of the color wheel, they become *tints* (a color plus white), *tones* (a color plus cool gray) and *shades* (a color plus black). Tints, tones and shades are not found on the color wheel.

Other Colors Not on the Wheel
Many of the pencil colors we use are not found on the color wheel. Pinks are tints of reds. Browns are shades of orange and red-orange. Beautiful golds and ochres are made from mixtures of red-violet and yellow.

Colored pencil manufacturers provide numerous mixtures of several different colors (pigments), such as Tuscan Red, Peacock Green and Celadon Green. You can mix these colors yourself by layering; however, it's a lot easier to pick up a pencil that is already the color you need or want. But remember, an area of any one color straight from the pencil (not layered) will be lacking in interest and will not contain the depth of color you can achieve by layering.

Color Schemes
A painting should present a sense of color unity—colors that relate logically to one another. Planning your work with a color scheme is a good way to achieve this goal. The color wheel can help show you which colors work best together.

ANALOGOUS—Analogous (an AL a gus) colors are colors next to one another on the color wheel. They are related colors since they have at least one color in common in their makeup. Mixing or layering these colors together works well, and when used side by side, these colors look as though they belong together.

COMPLEMENTARY—Complementary colors are two hues directly across from each other on the color wheel, for example, blue-green and red-orange. Mixing these two colors makes warm or neutral gray. Any two opposites will contain all three primary colors, and when three primaries are mixed neutralization of color occurs. The introduction of the third primary causes neutralization to begin.

SPLIT COMPLEMENTARY—This color scheme consists of one color plus the two colors on either side of its complement, for example, green, red-orange and red-violet.

DOUBLE COMPLEMENTARY—With this color scheme, you can utilize any two colors that are side by side, and the complements of both, for example, green, blue-green, red-orange and red.

TRIADIC—This is a more complex color scheme where you can utilize three colors that are equally spaced from each other; for example, green, orange and violet.

MONOCHROMATIC—This color scheme uses only one color in varying degrees of intensity and value.

color wheel made with three primaries

The three primary colors can create all other colors of the color wheel. Colors used here are Magenta, True Blue and Canary Yellow. When mixing colors in colored pencil from the three primaries, apply the yellow last, because the amount of wax in yellow will make other colors ride on top rather than mix.

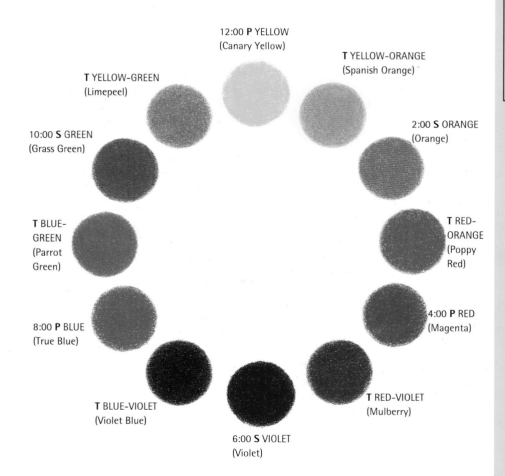

12:00 **P** YELLOW
(Canary Yellow)

T YELLOW-ORANGE
(Spanish Orange)

T YELLOW-GREEN
(Limepeel)

10:00 **S** GREEN
(Grass Green)

2:00 **S** ORANGE
(Orange)

T BLUE-GREEN
(Parrot Green)

T RED-ORANGE
(Poppy Red)

8:00 **P** BLUE
(True Blue)

4:00 **P** RED
(Magenta)

T BLUE-VIOLET
(Violet Blue)

T RED-VIOLET
(Mulberry)

6:00 **S** VIOLET
(Violet)

COLOR WHEEL MADE WITH MANUFACTURED COLORS

Each swatch here is made from one color straight from the pencil. **P** stands for *primary color*, **T** stands for *tertiary color*, **S** stands for *secondary color*.

Value is the word we use to describe the lightness or darkness of color or of areas of white, gray and black. The darkest value is black; the lightest value is white.

The ability to see values is one of the most important aspects of creating art. The play of contrast between values helps us send a message through our work. Paintings created with only the middle values will be passive and restful, perhaps to the point of being boring. The viewer's eye will move easily and quickly across the work because there is little contrast to stop it. On the other hand, paintings created with the extremes of the value scale will be dramatic, perhaps bordering on harshness. Too many abrupt jumps in contrast without restful areas of middle value may make the viewer want to quit looking altogether.

Full-range value work spans the values from light to dark and includes the midtones. The midtones or medium values will carry the total image while the extreme values (black and white) will add punch and detail for interest. To judge the value range in your work, try viewing it through a colored acetate value finder (page 20).

Local value refers to the actual value of something before changes by lighting. A red apple is dark in value; a yellow lemon is light in value. Outside of local value, lightness or darkness is created by light. Lots of light produces light values. Lack of light results in darker values (as in shadows).

Seven-Square Value Scale

A value scale is a series of steps or squares, each containing a value. The value scale below is seven squares but it could contain any odd number (nine, eleven, thirteen, etc.). The number of squares is odd because the middle square represents middle or medium value. The more steps or squares, the more gradual the change will be from one value to another. Making a value scale is good practice to learn control of pigment application as well as practice in seeing values.

LAY DOWN OUTLINE AND CENTER VALUES

Draw seven squares of the same size on white paper. Fill in the center square with a middle value of any color that is very dark when applied full-value. Black Grape was used for this example. Next, make a circle of medium value inside each of the remaining six squares. Your color will need to be applied in an even manner so the texture of the white paper doesn't interfere with the value you are trying to achieve.

COMPLETE VALUE SCALE

Now, turn each of the uncolored six squares into a different value by applying colored pencil with varying degrees of pressure. At one end you will have the lightest value (white). You'll have two squares to color on each side of the medium value. Fill them in with the same color pencil, working from medium toward light on two and working from medium to dark on the remaining two squares. The darkest square will correspond to the value of black. It's hard to believe that all circles are the same medium value! The circles appear darker or lighter depending on the surrounding value. The darker the surrounding area, the lighter the center circle appears to be.

HOW IS INTENSITY DIFFERENT FROM VALUE?

Intensity is easy to confuse with value, but you should learn to make the differentiation. Intensity means pureness or saturation. It also means the brightness or dullness of any color.

Don't mistake bright intensity with light value or dull intensity with dark value. A color can be high in value (light) but very low in intensity (lacking in a large amount of pure, bright color). Pink is a good example. It is a light color (high value), but is low in redness (intensity). Any color is usually at its brightest when it is pure and not mixed with another color.

Bright colors seem to come forward; dull colors tend to recede. To brighten a quiet color, layer it with a bit of a brighter analogous color close to it. Example: Add Spanish Orange to Orange or add Limepeel to Grass Green. To dull a color, layer a little of its complement with it. Example: Add Limepeel to Magenta.

Vary the color intensity in your work including both bright and dull colors. A mix of both is best. Use color brightness for emphasis.

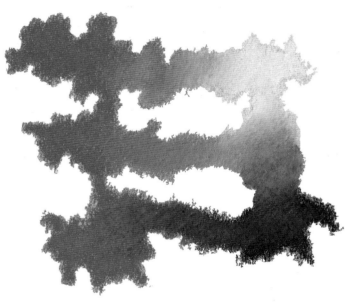

ADD THE ACHROMATICS TO LOWER INTENSITY
Make low-intensity colors by adding the achromatics (white, black, gray)—for example, pink (white added to red), grayed rose (cool gray added to red) and burgundy (black added to red). Notice that the values range from high (pink) through middle (grayed rose) to low (burgundy) even though the intensity of each color is low.

ADD A THIRD PRIMARY TO DULL COLOR
Each color on the color wheel contains some of one or two of the primary colors. But when you introduce some of the third primary (the primary color on the opposite side of the wheel), neutralization begins and the color mix dulls. Adding larger amounts of the opposite color (or complement) just dulls the mix even more. Mixing orange (red plus yellow) with blue (the third primary) lowers the intensity of both colors.

WHAT IS COLOR TEMPERATURE?

The color wheel can be divided into warm and cool hues. Colors near orange on the color wheel are thought of as warm; those near blue are cool. We equate warm colors with the color of the sun and of fire. The cool colors are those of grass and trees, of blue water, and of distant purple mountains.

Hues from yellow (12:00 on the color wheel) through red (4:00 on the color wheel) are considered the warm colors. Colors from violet (6:00 on the color wheel) through green (10:00 on the color wheel) are the cool hues. Yellow-green (11:00 on the color wheel) and red-violet (5:00 on the color wheel) are labeled either warm or cool depending on the ratio of the primary color to the secondary color present in each.

A color family is considered warm or cool, but that doesn't mean there can't be variances within the color family itself. In the red family, Scarlet Red is a warm red; it contains a hint of yellow. Magenta is a cool red; it contains a hint of blue. Cool reds are sometimes called blue reds.

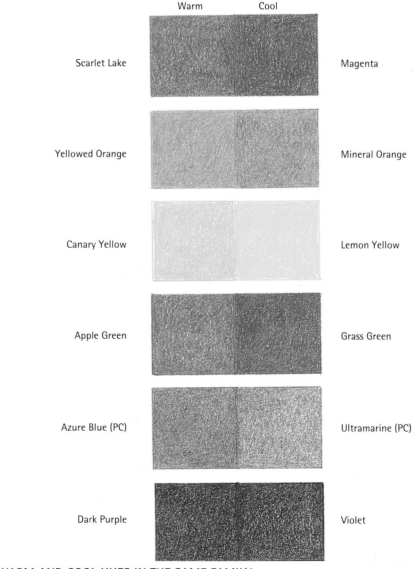

	Warm	Cool	
Scarlet Lake			Magenta
Yellowed Orange			Mineral Orange
Canary Yellow			Lemon Yellow
Apple Green			Grass Green
Azure Blue (PC)			Ultramarine (PC)
Dark Purple			Violet

WARM AND COOL HUES IN THE SAME FAMILY
Within each family, there are warm and cool examples.

HOW CAN I MAKE COMPLEMENTARY COLORS WORK FOR ME?

Complementary colors are located opposite one another on the color wheel. For example, red is the complement of green, red-orange the complement of blue-green, and so on, around the wheel. These colors are called complements because when they are placed side by side, they complement one other. A color will stand out or even appear brighter and more colorful when surrounded with its complement—or even with just a dot of the complement placed in that color.

AFTERIMAGES
Look at the center of the flag for thirty seconds. Then immediately look at a blank white area. The flag will appear—but this time, its colors will be correct. The afterimage is made of the opposites of the colors you stared at. This is a phenomenon called the law of simultaneous contrasts: Each color generates an afterimage of its own complement.

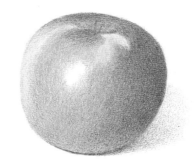

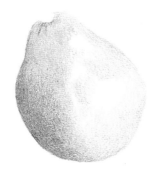

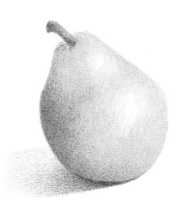

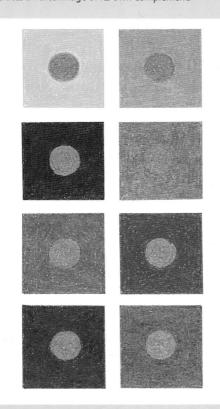

COLORS AFFECT ONE ANOTHER
The circles are the same color green. They seem to change because the color and value of the surrounding squares affect each differently.

ADD COMPLEMENTS FOR MORE NATURAL COLOR
Try adding some green or yellow-green to a red apple. Use a light-value lavender or violet to contour a yellow pear. Add some red or red-violet to a green leaf.

WHAT HAPPENS WHEN I MIX COMPLEMENTS?

When complements are mixed together, they neutralize or dull each other. This neutralization is easier to see with paint because the colored pigment fully mixes when the two colors are put together.

Colors produced by layering colored pencil are unlike color mixtures from any other medium. It is more a visual layering than a physical mix, and you will still see each separate color through every other color. It is difficult to create a completely neutral gray by layering two complements. Those same colors mixed together as paint could quickly turn to mud. Building neutrals from the complements used within your drawing will insure grays that are compatible with the rest of your color scheme.

Make a Complement Wheel

The complement wheel presents just a few of the many possibilities for mixing complements. It is divided like the color wheel—into color families.

Each family section gives you a chance to use four different colors from that family and mix each one with a member of the opposite or complement family in varying amounts. If you make a complement wheel, you will be able to mix many new colors and, at the same time, create a handy reference chart to which you can refer for mixing colors you may need or want. At the very least, completing the wheel will certainly get you acquainted with your pencils.

demonstration | **complement wheel**

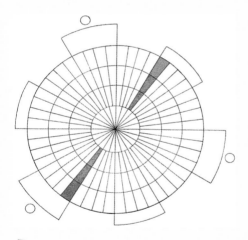

1 LAY FIRST COLORS

Separate your pencils into groups according to the color families on the color wheel. Select up to four pencils from each color family. Arrange these groups of four in a circle (like the color wheel) with the yellows at the top and the violets and purples at the bottom.

Choose a pencil from one of the families and choose a second pencil from the opposite family, for example, Pale Vermilion and Azure Blue (PC). Color a square on the outside ring with the Pale Vermilion, and color the opposite square on the outside ring with its complement, Azure Blue (PC).

2 CONTINUE COLORING

Still using the Azure Blue pencil, move down (toward the center of the wheel) into the next space in the second ring. This time, reduce your pencil pressure. The second space should appear lighter in value than the first.

Move down again into the inner circle and lighten pressure even more to color the space.

Then move across the center and into the inner circle on the other side. Color the new section, but reduce pressure even more.

Finish by using extremely light pressure and color the space just above the Pale Vermilion. Don't add any of the Azure Blue into the space containing the Pale Vermilion.

3 FINISH FIRST COLORS

Now do exactly what you did with the Azure Blue, but this time, use Pale Vermilion and work into the Azure Blue. Continue toward and across the center of the wheel, using progressively lighter pressure in each section. Don't apply any Pale Vermilion into the Azure Blue in the outer circle.

When you finish, the colors should line up, one changing gradually into the other.

4 FINISH THE WHEEL

To finish the wheel, continue mixing opposites
together across the wheel in varying amounts.

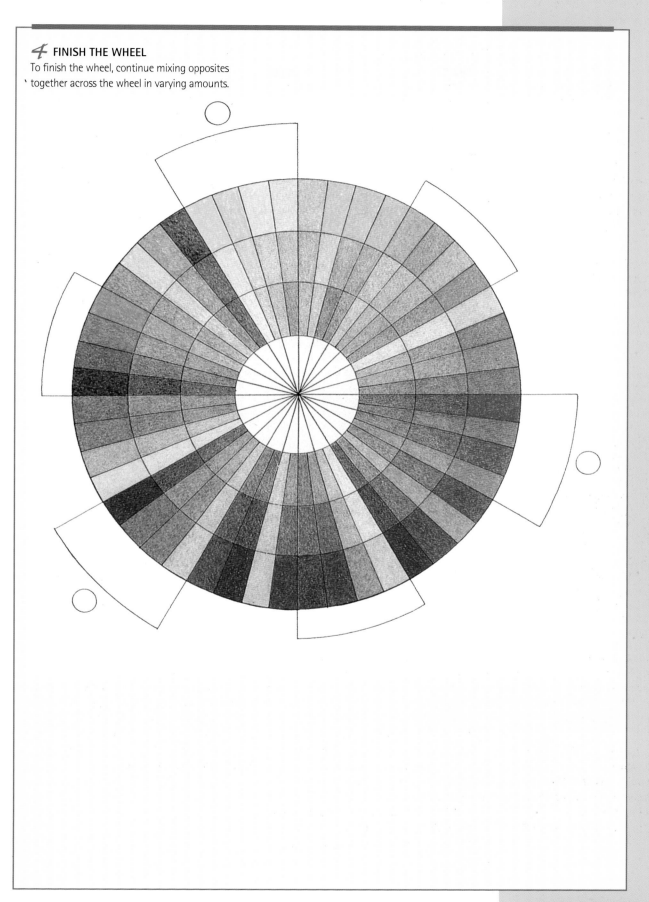

HOW DO I GET TO KNOW MY PENCILS?

One of the best ways to get to know how your pencils perform and what colors are available in any brand is to make one-layer color samples of each color, straight from a pencil, applied full-value. By doing this you'll become familiar with the colors and will begin to notice differences between colors. For example, of six reds, some may seem quite orange while others will appear darker and cooler.

The Color Fan

To view several similar colors at one time and to hold them in immediate proximity to the area of your work in question, consider making one or several color fans. A color fan is a convenient collection of small samples or chips of the colors you have available to you. For manageability, limit each fan to one brand of colored pencil. For example, if you work with a brand that offers 120 colors, your color fan may have an example of each color or you may choose to omit colors that you don't use, such as those with poor lightfastness.

When making color choices for your work you can spread the fan to view many colors at once or separate one blade to see a specific group of colors. Does the area you are working on need to be warmer or cooler? Duller or brighter? With all colors available at your fingertips, you will more easily make decisions regarding the color direction of your work.

demonstration | **color fan**

1 MAKE COLOR SAMPLES
Gather together all the colored pencils you use. Count them. You will need about one square inch (twenty-five square millimeters) of 2-ply drawing paper for each color. With an art knife and metal-edged ruler, cut the paper into 1" (25mm) wide strips. The length of a strip doesn't matter. With each pencil, apply a nickel-sized patch of full-value color and label it with the color name or color number.

2 BREAK INTO GROUPS
Once you have the strips completed, cut between each color to make color chips. Separate the chips by color and put them into groups. Put all the reds together, all the blues together, and so on. You will probably have six main groups (yellow, orange, red, violet, blue and green) and a few additional groups of browns and grays.

Then subdivide each hue group of chips by temperature, value or intensity. Because each person sees color a little differently, your groupings will be unique. Each subgroup will be comprised of colors that appear similar to each other. Each subgroup will be one blade of your color fan.

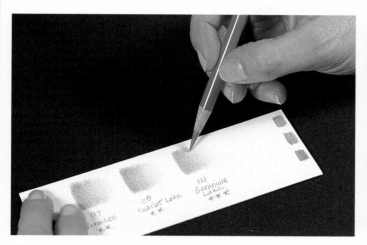

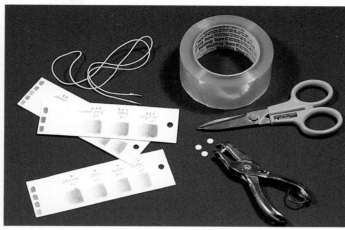

3 COLOR THE BLADES

You will need a 2" × 8" (5cm × 20cm) piece of paper (the same paper you used for your color chips) to make one blade for each subgroup. Count the number of subgroups of color you have to determine how many blades your fan will have.

Make spheres or patches of color on each blade, with patches of color ranging from dark to light. Label each color with its name or number. Spray lightly with workable fixative.

4 GATHER FINAL MATERIALS

With a heavy-duty paper punch, make a hole in the end of each blade for elastic cording to hold the whole thing together and serve as the hinge of the fan. Cover each blade front and back with clear 2-inch wide tape. This allows blades to slide against each other, protects colors from smearing and keeps blades clean.

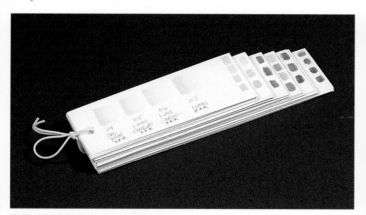

THE COLOR FAN ASSEMBLED

THE COLOR FAN SPREAD OUT

WHY ARE LIGHT AND SHADOW SO IMPORTANT?

We see shadows because there is light. The differences between light and shadow are what enable us to see and move through our three-dimensional world. Shadows help define the form and volume of objects. If everything were the same color and value, what a terrible time we would have, bumbling our way around, continually bumping into things we couldn't see.

Form Shadows

Shadows that appear on an object are called *form shadows*. They define the surface of the object and are usually made up of gradually changing values. They appear only on the object itself. Their value range is directly related to the local color of the object and the power of the light. They may contain reflected color.

Cast Shadows

The shadows cast by an object onto another surface are called *cast shadows*. Cast shadows are usually distorted forms of the object that cast them. They lean away from the light source and are affected by changes in the surface on which they are cast. The closer they are to our eye level, the more slender they appear. Their value is determined by the value of the surface on which they fall and the strength and angle of the light. They may contain color reflected back from the object that cast them.

Create Realism With Light and Shadow

Your world is real. If you want your representation of it to look real, then you must first learn how to see. Once you see and understand what you are looking at, it will be easier for you to create the illusion of reality. Part of learning how to see consists of understanding light and shadow, the gradually changing values and the differences in contrast. Then you need to be able to smoothly re-create the gradual changes.

The ability to realistically render objects relies on your observation and your ability to reproduce what you see. To render objects realistically, you must create certain illusions that convince viewers they are seeing in three dimensions that which you have rendered in two. Shading is one of those illusions. Not only must you learn to make smooth gradual changes in value, you must be able to see and interpret value differences. Understanding value is even more important than understanding color.

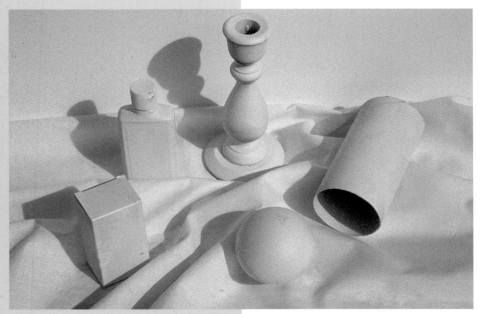

FORM AND CAST SHADOWS
Look at the differences between form shadows and cast shadows. The changes in value are what let you differentiate between objects and surfaces of the all-white arrangement.

COMPLEX OBJECTS

Carefully observe what shadows do. Where surface curves are gentle, values gradually change. Where edges or sudden surface changes occur, value changes are more abrupt with greater contrast. An object is capable of casting its own shadow on itself. In that case, the shadow acts as both a form and a cast shadow, and as it follows the surface of the object, it also helps to describe its form.

FABRIC FOLDS

Draped or arranged fabric consists of convex and concave tubes or cylinders. These tubes are usually not even, but bend, crinkle, curve and overlap one another. The value change is gradual over curves and rounded areas, but where there is an edge, a fold or a crease, the change is sharp and abrupt.

ROUNDED OBJECTS

Smooth gradual shading changes a two-dimensional circle to a three-dimensional sphere. Curved surfaces have gradually changing values with no abrupt changes from dark to light. Shadows curve around rounded objects—not straight across them.

FLAT SURFACES

Flat surfaces, or planes, usually accept light evenly, but when turned at different angles to the same light source, each plane will be a different value. A flat surface exhibits little (if any) change in value.

Color, light and shadow all work together to create a mood. Express yourself with color and value. You can create sentiment and passion with the colors you choose and the way you use them.

The Color of the Light

The light you use in your work can portray the time of day and the season of the year. Morning light may be golden and represent tranquility—the peaceful time before the hustle and bustle of the activities of the day. Midday light has the brilliance of high noon. Light of late afternoon creates dramatic, long shadows. The cool, crisp, pale light of spring gives way to the warmer (redder) light of summer and fall. Winter offers cold light and stark contrasts.

Backlighting

Backlighting occurs when the main source of light is coming from behind the subject. Since the viewer is looking into the light source, the subject (between the viewer and the light source) appears at least partially in shadow. Backlighting a subject can produce a dramatic painting, but additional challenges are presented regarding the amount of detail put into the subject. Strong backlighting produces a halo effect along the edges of objects. There must be enough light and detail to recognize what the subject is and prevent it from looking like a flat silhouette against the strong light but not so much detail that you lose the dramatic effect of backlighting.

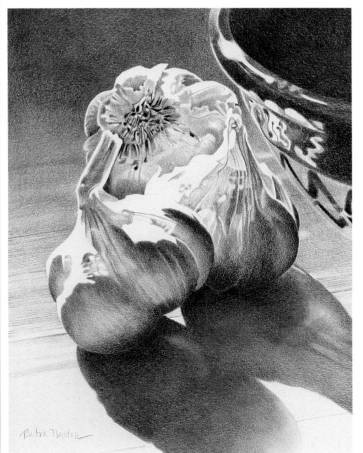

BACKLIGHTING
Backlighting is especially effective when combined with a certain amount of reflected light and interesting shadows. Cast shadows will move forward from the object, toward the viewer, and carry the viewer into the picture frame and to the main subject.

BACKLIT GARLIC
Barbara Benedetti Newton
Colored pencil on Rising Stonehenge
15" × 11" (38cm × 28cm)
Collection of Donna Preusser

Contrast

Contrast means differences. With regard to art, it usually has to do with large differences in value. White and black are high contrast—at opposite ends of the value scale. Between white and black lies the enormous range of values from light to dark. You need to make sure your art has a wide enough value range that is effective for its purpose.

Contrast is what captures the viewer's attention. It is a useful tool in directing the viewer's eye to a specific area of your painting. We tend to look first at the area of greatest contrast, so by giving your center of interest the greatest value change, you lead the viewer's eye immediately to the most important part of your art.

Working within a narrow range of values creates objects that are hard to see, and the work loses impact. A good way to judge your values is to view your art through colored cellophane (see page 20, Colored Acetate Valuefinder).

Working With Keys

Keys are grouped values. Using only very high or very low values in a piece of art can create mood and impact. When values are close, it becomes more and more difficult to distinguish objects, so keep that in mind as you decide what key to use.

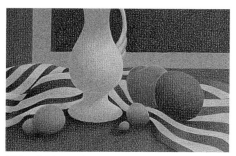

FULL CONTRAST
The most effective use of contrast employs the entire range of values between and including black and white. It is known as chiaroscuro (kye ro SCUR oh).

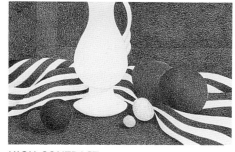

HIGH CONTRAST
Use the very darkest and the very lightest values for high contrast. This method is known as tenebrism (ten a BRIZ em).

HIGH KEY
High-key or light-value colors are what we call pastels. They usually represent delicacy, lightheartedness or frivolity.

LOW KEY
Using only low-value colors can create an entirely different mood—one of mystery and intrigue, or one of ponderousness, heaviness or sadness.

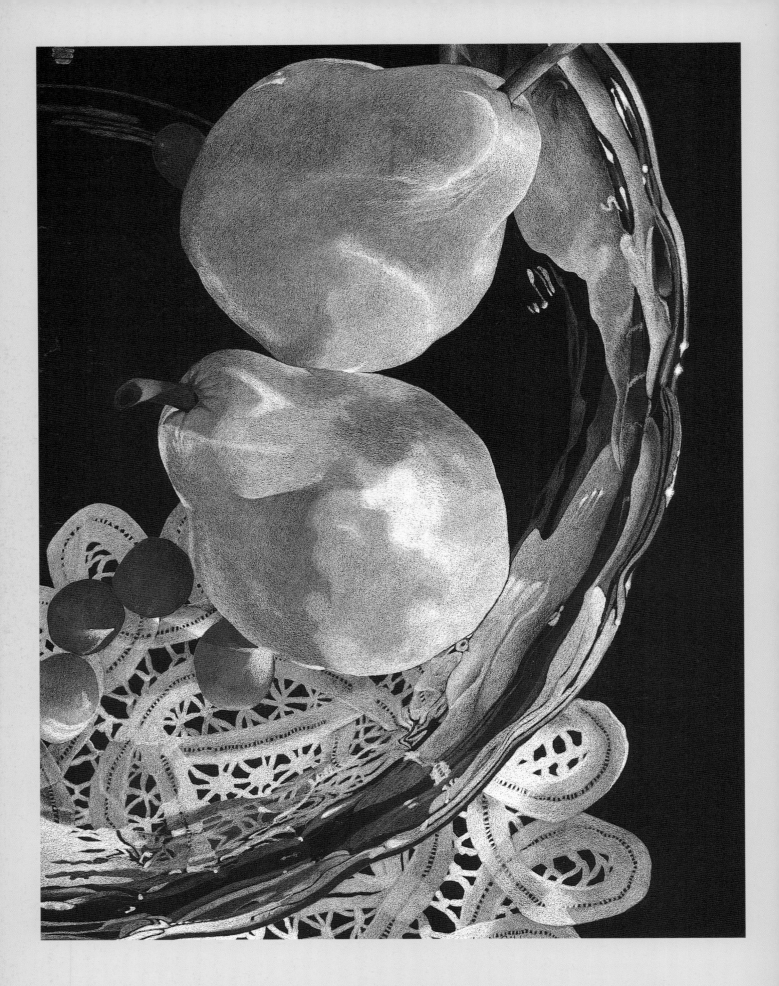

reflection and transparency solutions

The appearance of metal doesn't come from using a metallic colored pencil. You create metal by using regular pencil colors. When metal is polished and shiny, its surface reflects whatever is around it. The shapes of the reflections are affected by the form of the metal object and are distorted as they curve and swirl to follow the shape of the surface. The colors of the reflections are the colors of the objects reflected in the surface added to the local color of the metal.

Since you can't just pick up a "glass-colored" pencil and use it to draw glass, you can learn how to create the look of sparkling glass by placing strong darks next to bright whites. Light is fractured and diffused as it travels through glass, giving glass the appearance of fragility. Glass reflects light back at the viewer but also allows some light to pass through, which can result in visual distortion.

Once you know what to look for and learn the characteristics of glass, colored transparencies and metal, it will be easy to include these objects in your own work.

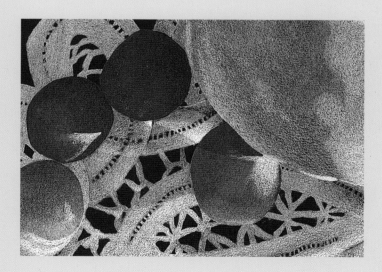

PEAR DIEM (DETAIL)
Janie Gildow
Colored pencil on black Letramax
16¾" × 11½" (43cm × 29cm)
Collection of E. Louise Baldwin

HOW DO I CREATE THE LOOK OF BRASS?

Brass is a colored metal. To make the reflected color look realistic, you need to mix the local color of the brass with every color reflected in the surface. Choose from ivory, cream, ochre and burnt sienna hues to create the brass color.

Values in reflective metals range from very high to very low. Make sure that your dark values are dark enough. The contrast between light and dark shapes, and sharp clean edges create the look of metal. Watch for a reflection to travel up the side of the object. It appears and disappears, as its shape is affected by the contours of the object.

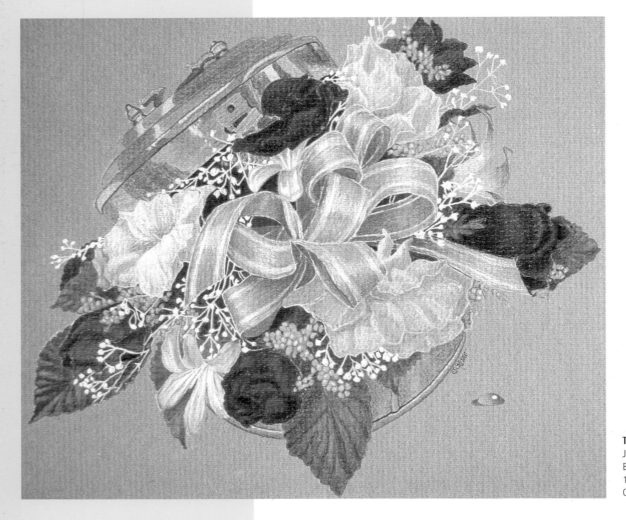

TREASURES
Janie Gildow
Bainbridge Papermat
10" × 8½" (25cm × 22cm)
Collection of the artist

demonstration | **brass container**

1 BEGIN TO ESTABLISH VALUES

After completing the sketch of this brass container (see page 120), use Dark Sepia to begin development of the light and dark areas. Make a complete value study with this one color.

2 FINISH THE VALUE STUDY

Continue to establish the lights and darks with your Dark Sepia pencil. Keep edges clean and sharp and make sure the darkest areas are dark enough to create a full range of values.

Slate Grey Slate Grey Light Ochre/Jasmine

White highlight Brown Ochre/Raw Sienna Raw Umber/Brown Ochre

3 BEGIN TO COLOR THE BRASS

Now, begin to add the color of the metal right over the Dark Sepia value study. Lay Raw Umber and Brown Ochre over the dark- and middle-value areas.

Then layer Raw Sienna and Brown Ochre over the medium- and light-value areas. On the very lightest areas, layer only Light Ochre and Jasmine. Save some of the white areas. You'll need them for sparkle and contrast.

Add some of the reflected color with Slate Grey. Notice how the reflected Slate Grey travels right up the side and front of the brass container (on the right) and also appears less intensely on the inside of the container (on the left).

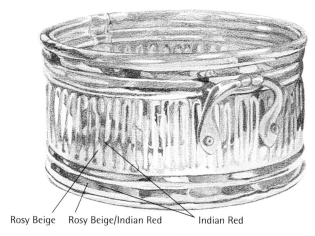

Rosy Beige Rosy Beige/Indian Red Indian Red

4 ADD MORE REFLECTED COLOR

Use Rosy Beige and Indian Red as the reflected color on the left side of the container. Color right over the darker values with the Indian Red and over the lighter values with the Rosy Beige. Each reflected color is a mix of the color of the brass and the color of the reflected object.

5 COMPLETE THE CONTAINER

Complete your application of the brass color with Light Ochre and Jasmine, everywhere except the areas to be left white. You can use a colorless blender to burnish at this point if you wish. Burnishing makes the metal look smoother, shinier and more metallic.

REFLECTION AND TRANSPARENCY SOLUTIONS **73**

HOW DO I CREATE THE LOOK OF COPPER?

materials list

Surface
 Rising Stonehenge White

Pencils
 Black Grape
 Terracotta (PC)
 Pink
 Pale Vermilion
 Tuscan Red
 Indigo Blue
 Jade Green
 Sunburst Yellow

The base color of copper is warm. When light is cast on its surface it changes in color ranging from pink to yellow to golden red. When copper is very shiny, objects may be identifiable within the reflection but will be altered in color by the base color of the metal.

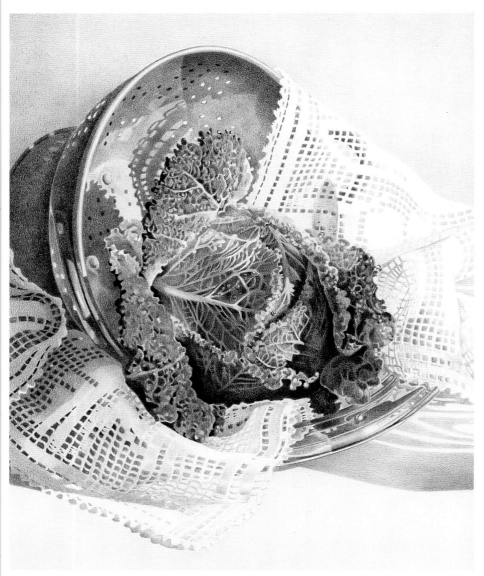

CHERISHED
Barbara Benedetti Newton
Strathmore 500 Bristol Plate
21½" × 17" (55cm × 43cm)
Collection of the artist

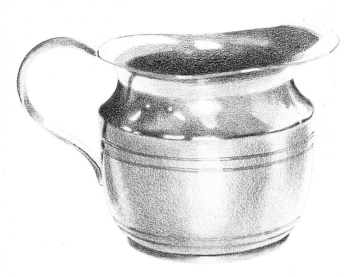

1 START WITH A FOUNDATION COLOR

After sketching this copper pitcher (see page 120), apply Black Grape across the value range to establish a foundation layer.

2 ADD THE BASE COLOR

Next, add Terracotta on top of the Black Grape foundation layer, applying it heavier along the rim, decorative rings and base.

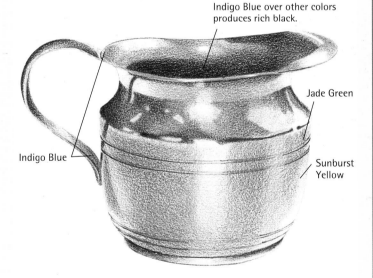

Indigo Blue over other colors produces rich black.

Jade Green

Indigo Blue

Sunburst Yellow

3 BUILD THE COLOR

Add warmth to the metal with a light layer of Pink over all except the lightest, uncolored highlights. Add Pale Vermilion to the surface of the pitcher to bring it forward. Use Tuscan Red to deepen and warm up shadows inside the pitcher, where the handle reflects on the pitcher, and to define the edges.

4 ADD HIGHLIGHTS AND INTENSITY

Finally, add Indigo Blue to darken and cool the interior of the pitcher as well as for highlights along the rim and handle. Layer Pink and Jade Green together for areas of the rim and to help the sides of the pitcher recede. Use Sunburst Yellow for highlights.

HOW CAN I PORTRAY "COLORLESS" METAL?

materials list

Surface
Rising Stonehenge
White

Salmon Pink
Celadon Green
Sand

Pencils
Black
Black Grape
Ultramarine

Other
Reusable adhesive
Battery-powered
eraser

Silver is a relatively colorless metal. Because of this, the colors of the reflections it carries remain unaltered. A white tablecloth appears white, a red cherry appears red. Overall, silver usually takes on a warm glow when portrayed in artificial light or candle-light. Shadows can range all the way from warm to cool as they fade from delicate to intense.

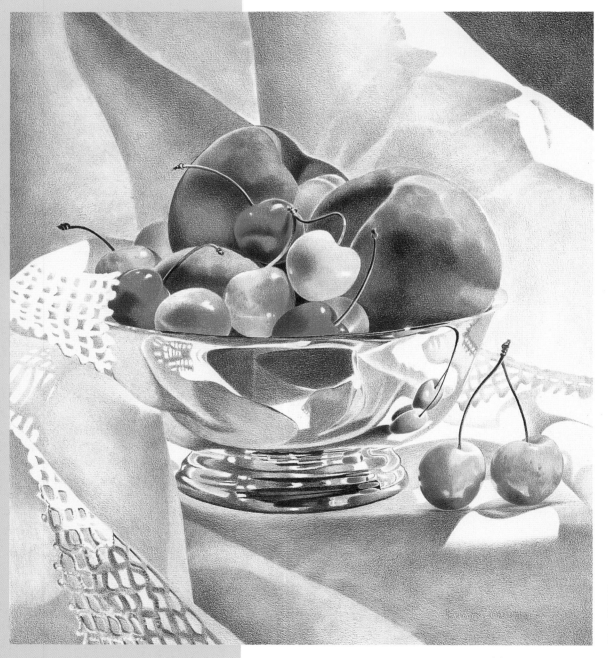

A CHANGE OF HEART
Barbara Benedetti Newton
Strathmore 500 Bristol Plate
17¼" × 14¾" (44cm × 37cm)
Private collection

1 BLACK FOUNDATION

After completing a sketch of this child's antique porridge bowl (see page 120), use Black to create a value study. Portray the character in the metal by using all values of the scale from very dark to white left for highlights.

2 WARM THE BLACK

Apply Black Grape to warm the harshness of the Black, going darker or lighter depending on the underlying values of the Black.

3 ADD INTEREST

Add touches of Ultramarine for interest, going with a heavier or lighter application depending on the underlying values.

4 AGE THE SILVER

Apply Salmon Pink for the mellow glow of old silver. Layer it lightly inside and outside below the rim of the bowl, and in the center of the bottom and of the outside of the bowl. Several spots of pink on the handle add interest. Use Celadon Green inside the bowl and on the rim, over light-colored areas, but not over the pink. Apply Sand sparingly to uncolored areas to give brightness. Soften passages of color and edges as needed with reusable adhesive. Use a sharpened battery-powered eraser for dramatic highlights along the rim, on the edges of the handle, and inside and outside the bowl to create dents and character.

HOW DO I CREATE THE LOOK OF METALLIC GLAZE?

materials list

Surface
Strathmore Bristol
regular surface
2-ply

Pencils
Dark Umber
Black Grape
Tuscan Red

Dark Brown
Burnt Ochre
Peach
Terra Cotta
Pale Vermilion
Light Aqua

Other
Colorless blender

Metallic glaze looks just like metal and has the same reflective characteristics. However, glazes can be any color. Once you have determined the combination of colors needed to reproduce the local color of the glaze, all you have to do is mix the local color with each of the colors reflected in the object. Save some whites for contrast and make sure your dark values are dark enough. The glaze in this demonstration is a warm dark brown with hints of copper. It affects every color reflected in it. The important thing to remember is that no matter what colors you choose for the glaze, by matching the values and duplicating the distorted shapes, the object will look reflective.

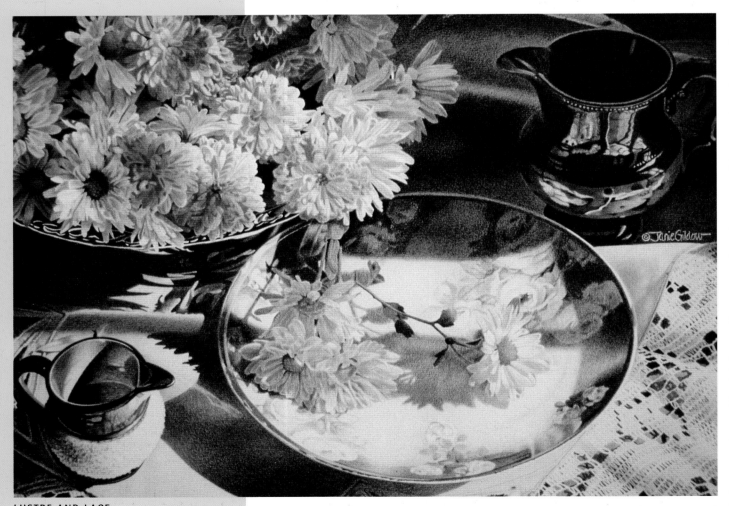

LUSTRE AND LACE
Janie Gildow
Colored pencil on museum board
12¾" × 18" (32cm × 46cm)
Collection of Mr. and Mrs. Raymond Stone

1 DEVELOP THE VALUES

In this step you will apply three colors—one right over the top of the other and in exactly the same way. This combination establishes the values for the pitcher.

After sketching this pitcher (see page 120), apply Dark Umber to establish values. Lighten pressure as you near the highlights (vertical shape down the center of the pitcher). Keep all other edges clean and sharp.

Then apply Black Grape right over the Dark Umber in exactly the same manner. Layer Tuscan Red over these colors in the same way. These layers give the foundation for the local color of the glaze. When you finish this step, your pitcher will already look shiny and reflective.

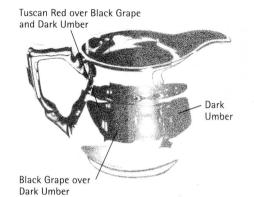

Tuscan Red over Black Grape and Dark Umber

Dark Umber

Black Grape over Dark Umber

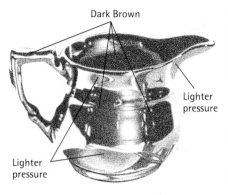

Dark Brown

Lighter pressure

Lighter pressure

2 BEGIN THE LOCAL COLOR OF THE GLAZE

Add a layer of Dark Brown over the three layered foundation colors. Watch the value changes and change your pencil pressure accordingly. This color warms the foundation and sets the stage for the glaze color.

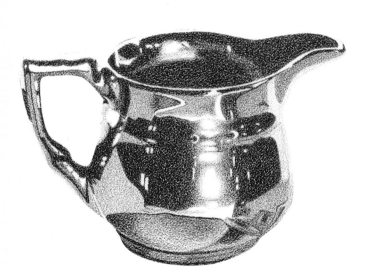

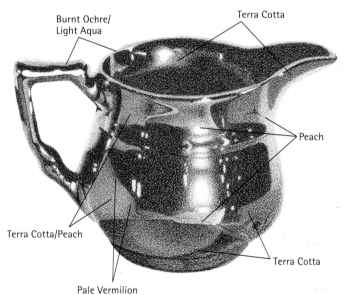

Burnt Ochre/ Light Aqua

Terra Cotta

Peach

Terra Cotta/Peach

Terra Cotta

Pale Vermilion

3 COMPLETE THE LOCAL COLOR

Layer Burnt Ochre over everything but the saved white highlight areas. Vary pencil pressure according to value. The Burnt Ochre combined with the Dark Brown completes the local color mix of the glaze and gives it a warm coppery glow.

4 ADD THE REFLECTED COLOR

Add Peach over the lighter areas, saving highlights. Then add Terra Cotta over all the Peach, to enrich areas of reflected color. Then add Pale Vermilion to the darker areas of the reflected color. Use a combination of Burnt Ochre (applied very lightly) and Light Aqua along the rim and on the top of the handle. Check your values to make sure your darks are dark enough. If you want to burnish, do it now using a colorless blender. Work from light to dark with the blender and wipe the point periodically to keep from transporting unwanted color into any area.

WHAT TECHNIQUES WILL HELP ME CREATE COLORED GLASS?

<table>
<tr><td colspan="2">materials list</td></tr>
<tr><td>Surface</td><td>Olive Green (PC)</td></tr>
<tr><td>Rising Stonehenge</td><td>White</td></tr>
<tr><td>White</td><td>Other</td></tr>
<tr><td>Pencils</td><td>Cotton cloth</td></tr>
<tr><td>Aquamarine (PC)</td><td>Rubber cement</td></tr>
<tr><td>Indigo Blue</td><td>thinner</td></tr>
<tr><td>Raspberry</td><td>Latex gloves</td></tr>
<tr><td>Peacock Blue (PC)</td><td>Frisk Film</td></tr>
</table>

Colored or tinted glass is easy to create in colored pencil when the color of the glass is laid in all at once and solvent is applied to dissolve the pencil pigment. This time-saving technique provides you with a toned ground of middle value from which you can work toward each end of the value scale. Once this middle value is established, you can see which areas need to be darker than the foundation and which areas (highlights) need to be burnished with white.

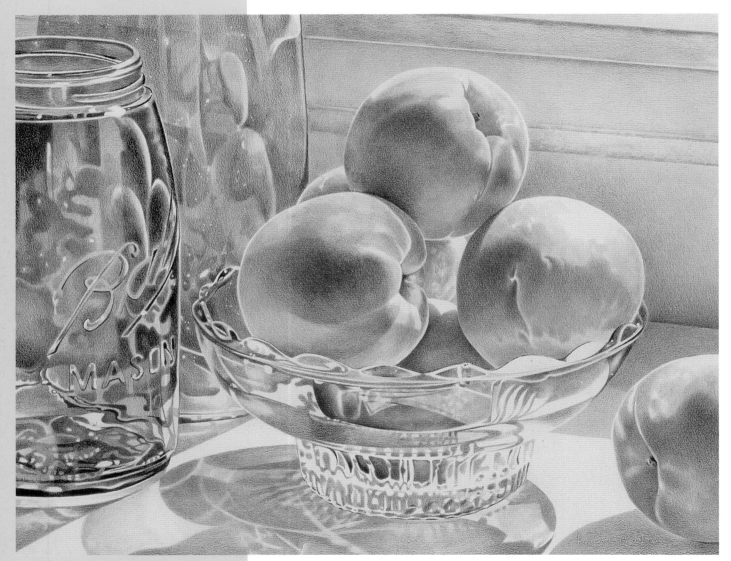

SWEETNESS AND LIGHT
Barbara Benedetti Newton
Colored pencil on Strathmore 500 Bristol Plate
15¼" × 19" (39cm × 48cm)
Collection of Susan De Lisa

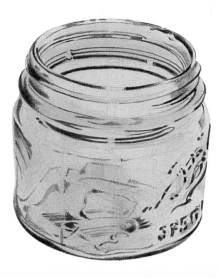

1 FOUNDATION COLOR

After sketching in the drawing of this jar (see page 121), use casual strokes to lay in the medium-value color with Aquamarine. Strokes can be random, and your pencil tip does not have to be sharp. Apply extra color in the areas you expect to be darker in the finished drawing.

2 DISSOLVE THE PIGMENT

With a cotton cloth around your latex-gloved index finger, rub rubber cement thinner into the pencil pigment with small circular strokes. This dissolves and blends the foundation color. Use a Frisk Film template to protect the white paper surrounding the jar.

3 ADD THE DARKEST DETAILS

Layer Indigo Blue and Raspberry to create dark details. Also, use the Indigo Blue and Raspberry alone in selected areas for details and spots of color.

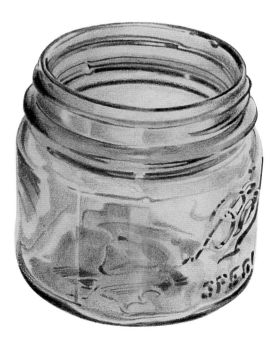

4 MEDIUM AND LIGHTEST VALUES

Use Peacock Blue and Olive Green separately as well as layered together to produce the medium values. Burnish with White in the lightest areas of the jar and rim to create the look of transparency of the glass. Also add a heavy application of White next to the darkest areas in the letters on the jar.

CAN I "DRAW" GLASS ON A WHITE GROUND?

materials list

Surface
Fabriano Uno HP 140-lb. (300gsm)

Pencils
Black Grape
Violet
Violet Blue
Greyed Lavender
Sand
Peacock Green
True Green (PC)
Deco Aqua
Light Green

When you color glass on a white surface, you must color everything except the white highlights. Glass reflects light and pulls surrounding color into itself. It distorts every shape to follow its contours.

Rounded containers tend to invert color. Notice in this demonstration how the dark background color appears in the bottom half of the container and how the lighter color repeats in the top. Glass that looks colorless usually does have some color where it thickens. This container has a green tint, and it mixes with the background colors.

The secret of making sparkling glass depends on your faithful representation of its values. Once you complete the value study (or grisaille), your drawing will already look like glass. The dark values in combination with the pure white highlights give the glass its sparkle.

Remember to keep edges hard. Highlights should be as white as you can make them, so define them early and leave them as the white of the paper. You can see reflections on the outside of the glass. You can see reflections on the inside of the glass. Every reflected shape is distorted. Notice the slanted background line and how it distorts as you view it through the glass. Remember that you're not only looking at the outside of the glass, but through it. You see inside, outside and behind the glass—all at the same time.

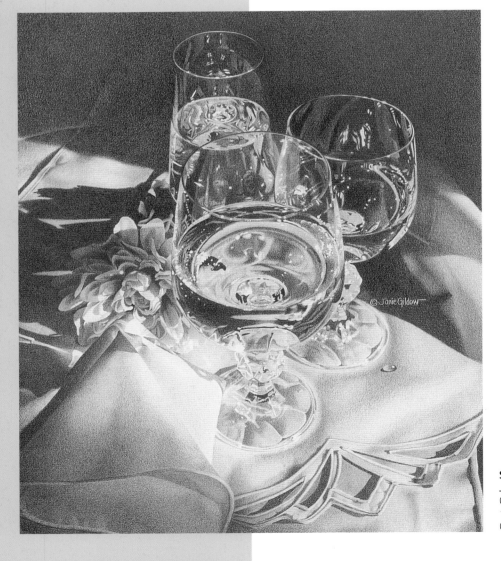

SPARKLERS
Janie Gildow
Colored pencil on Rising Stonehenge
15" × 11½" (38cm × 29cm)
Collection of the artist

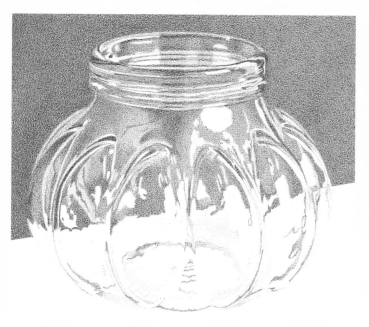

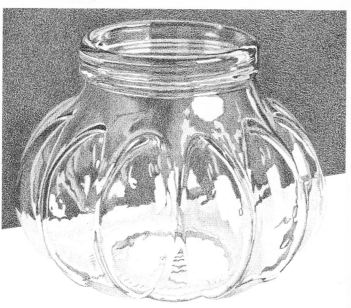

1 SET THE VALUES

After sketching the glass jar (see page 121), apply values to the entire drawing with Black Grape. Vary pencil pressure to create strong darks and delicate lights.

2 COMPLETE THE BACKGROUND COLOR MIX

Apply a layer of Violet right over the Black Grape. Keep the values and pencil pressure the same as you did with the Black Grape in step one. Then, over the Violet, apply Violet Blue in exactly the same manner.

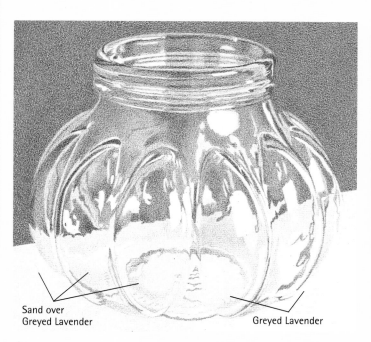

Sand over
Greyed Lavender

Greyed Lavender

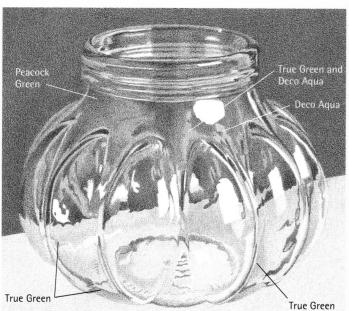

Peacock
Green

True Green and
Deco Aqua

Deco Aqua

True Green

True Green

3 LAYER THE LOCAL COLOR OF THE SURFACE

Apply a layer of Greyed Lavender to the surface under the glass. Inside the container, apply it to all the middle- and light-value areas. Leave the highlights white. Then add a layer of Sand over the Greyed Lavender in exactly the same manner.

4 TINT THE GLASS

Layer Peacock Green over the darkest violets. Layer True Green over the middle values and layer Deco Aqua and Light Green alone. Then, use these same colors to lightly tint all the glass below the background line just enough to make it slightly different from the area outside the glass.

HOW DO I "DRAW" GLASS ON A COLORED SURFACE?

materials list

Surface
Crescent Copley Gray mat board

Pencils
White
Black
Jasmine
Tuscan Red

Other
White Saral transfer paper

When you allow a medium-value drawing surface or ground to contribute to the drawing instead of covering it up with pigment, you'll find that creating the image is a simplified and quick process. Pure whites next to dense darks give your glass sparkle. Areas of light haze help to show the form of the glass object. When drawing glass on a medium-value surface, add at least two other darks and two other lights.

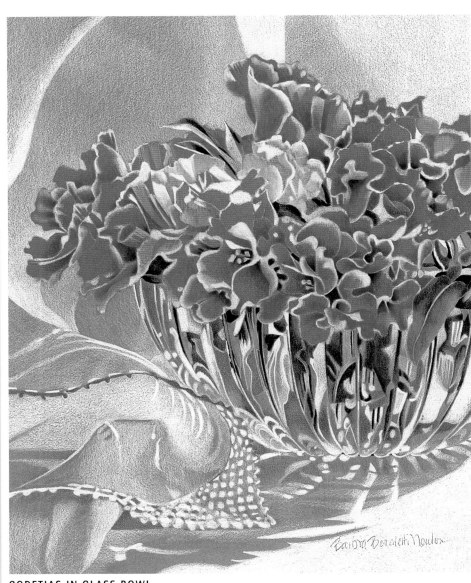

GODETIAS IN GLASS BOWL
Barbara Benedetti Newton
Colored pencil on Crescent mat board
12¾" × 10½" (32cm × 27cm)
Collection of Norma MacArthur

1 WHITE LINE DRAWING

When working with a drawing surface that is medium value or darker, use a white line drawing for your subject. Transfer a sketch of this overturned glass (see page 121) to Crescent Copley Gray mat board with white Saral transfer paper.

2 DEFINE THE LIGHTEST VALUE

Use a White wax- or oil-based colored pencil and apply the brightest whites with firm pressure. Heavy pressure may be necessary; a sharp pencil tip is not needed. Now you have two values, the lightest (white) and the medium value of the paper.

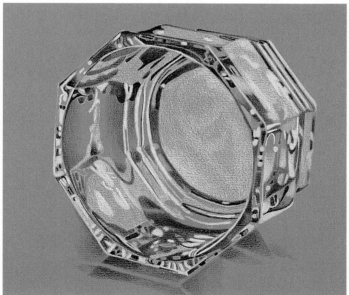

3 GIVE FORM TO THE GLASS

Now, add the next lightest value by lightly applying White pencil, allowing the value of the paper to show through the pigment. Use a light touch and a sharp pencil tip. If your paper has a distinctive texture, it will become apparent in this step.

4 ADDING THE PUNCH

Add Black pencil for intense blacks when applied heavily, and a darker-than-medium value when applied lightly with a sharp tip. Add Jasmine and Tuscan Red in selected small areas for interest. You can also use Tuscan Red to enrich the intense black where desired.

HOW DO I DEAL WITH THE FRACTURED VIEW WATER CREATES?

materials list

Surface
Rising Stonehenge
White

Pencils
Black Grape
Indigo Blue
Limepeel
Burnt Carmine
(DA)

Non-Photo Blue
Light Cerulean
Blue
Sand

Other
Thin, sturdy piece
of paper
Reusable adhesive

This subject may at first appear overwhelming in its complexity, but it is easily accomplished when broken into sequential steps. The contrast of dark shapes next to bare white paper makes the object sparkle. Middle values give form and volume information to the viewer. There are lots of crisp edges in the vase that add interest, but be careful not to be too precise or you will end up with a sterile look to your work. Instead of using a ruler, place a piece of thin, sturdy paper (like that of a photograph) on your work and color up against the edge of the paper (photo). Verithin pencils are capable of minute details, but too much detailed rendering gives a mechanical appearance. The challenge in creating water that appears to be fractured is not the colors used in the end, but rather the critical value and shape contrasts set up in the foundation, before color is applied.

demonstration | fractured view through water

1 COMPLETE THE DARKEST AREAS FIRST
After completing a detailed line drawing of this vase, water and stems (see page 121), apply the darkest values with Black Grape. This will give you a "road map" for what at first appears to be a complex and challenging subject.

2 ADD FORM AND VOLUME
Next, use Black Grape to fill in the remaining values, leaving the white paper uncolored for the lightest values. Pay close attention to shapes and use a sharp tip to achieve a good range of value in this foundation of your work.

3 ENRICH THE FOUNDATION
Apply Indigo Blue on top of the Black Grape foundation in the darkest areas. Pay special attention to nuances in values that give the look of light through water. Lift color with reusable adhesive if necessary.

♪ **ADD MORE COLOR**

Layer Burnt Carmine over the darkest areas of the green stems that you want to bring forward (not the stem on the far right). Add areas of Non-Photo Blue and/or Light Cerulean Blue in the lower third of the vase (left side) to suggest water. Reflect these same two blues sparingly in the spots of color along the beveled planes of the vase (full length, right side). Apply Sand to the green stems where they are lightest to give the impression of light hitting them through water. Lift color to soften the appearance of the stems. Also, lift color from one or two small areas of the surface of the vase to show light hitting and defusing.

4 **ADD GREEN**

After the foundation is complete, lay in Limepeel in the green areas of the stem and reflection.

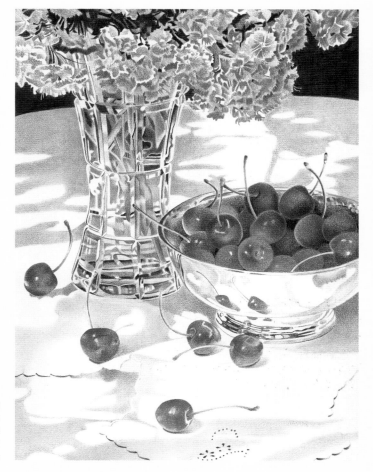

A WORLD OF GOOD
Barbara Benedetti Newton
Colored pencil on Strathmore 500 Bristol Plate
16" × 11¾" (41cm × 30cm)
Collection of Beverly Collin

HOW CAN I CREATE INTERESTING REFLECTIONS IN WATER?

materials list

Surface
Rising Stonehenge
White

Tuscan Red
Mineral Orange
Ochre (PC)

Pencils
French Grey 30%
Slate Grey
Indigo Blue (VE)
Black Grape

Other
Reusable adhesive
Battery-powered
eraser

How interesting could a simple glass of water be? The answer may depend on the angle of viewing and what the glass is sitting on. In this demonstration, water fills a utilitarian clear glass, which sits on a woven coaster. The distorted image of the coaster in the bottom of the glass is expected, but look at the surface of the water. The image directly under the glass is carried up through the water to the top and appears to float on the surface with relatively little distortion.

LACE AND LACE
Janie Gildow
Colored pencil on Strathmore charcoal paper
25" × 18" (64cm × 46cm)
Collection of Mr. and Mrs. Fred James

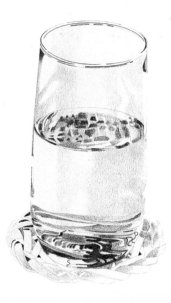

1 DEFINE THE GLASS

After completing the drawing of this glass of water and coaster (see page 122), use a light application of French Grey 30% to define the form and volume of the glass. Do not apply color in any area you want to save for highlights, which will require the pure, uncolored white paper. To aid in the believability of transparency, use reusable adhesive to soften the edges of color and to lift soft-edged highlights.

2 ADD DEPTH AND WEIGHT

Use Slate Grey to enrich the gray. Keep the application light to retain the transparent look. Create the surface reflection and the distorted image in the bottom of the glass with a darker foundation of Slate Grey. With a sharp tip on the pencil, define a few areas of the rim with the Slate Grey. Keep the rim lines crisp.

3 ADD CONTRAST

Add Indigo Blue to give the drawing punch. The darkest values are reversed by the water. Above the waterline they appear left of center, and at the bottom of the glass they are lower right. Fine lines are essential for the rim, and the Indigo Blue will work well. Notice the breaks in the rim lines that imply the fragility of glass.

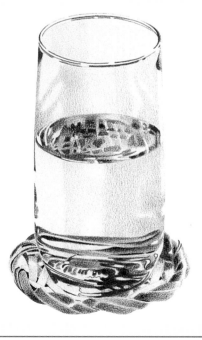

4 ADD COLOR

Apply Black Grape and Tuscan Red to warm the reflections and rim in selected areas. Apply Mineral Orange next and then some Ochre to the coaster underneath the glass and in its reflections to build the local color of the straw. Leave the paper uncolored (pure white) for highlights along the rim of the glass, down the left side and in the base, and in the small areas on the surface of the water. Use reusable adhesive to lift color as needed to soften for transparency in the body of the glass. Erase tiny spots of color for highlights using a battery-powered eraser sharpened to a point.

HOW DO I MAKE OBJECTS DISTORT IN WATER?

Pencil 1

Pencil 2

Pencil 3

Pencil 4

Pencil 5

Pencil 6

Look at these drawings to identify each pencil. You can follow the steps of the demonstrations and work on all the pencils in each step, or you can complete one pencil at a time.

The lightly tinted vase in this demonstration takes much of its color from the pencils arranged in it. They reflect their combined colors into the contours of the vase, into its rim, and into the edge of the water's surface. Both the glass and the water distort the pencil shapes. Wherever the pencils extend below the surface of the water, they look bent or broken. The view down through the surface of the water is different from the view into the vase from the side. The water itself is invisible: It is only by its effects that we know it is there. Once you identify and follow each pencil tip to its end, this seemingly complicated project becomes quite simple.

materials list

Surface
Strathmore Bristol
 Plate acid-free
 2-ply

Pencils
Indigo Blue
Sepia
Warm Grey 50%
Black Grape
Peacock Blue
Dark Umber
Light Umber

Dark Green
Deco Blue
Light Aqua
Peacock Green
Light Green
Parma Violet
Violet
Goldenrod
Deco Aqua
True Blue
Burnt Ochre
Jasmine
Slate Grey

demonstration | objects distorted in water

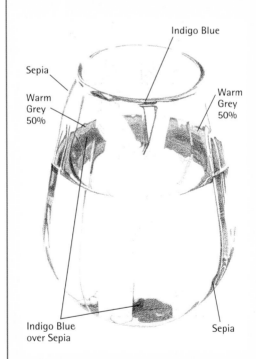

Indigo Blue

Sepia

Warm Grey 50%

Warm Grey 50%

Indigo Blue over Sepia

Sepia

1 DEFINE THE VASE AND BEGIN THE WATER

Once you have completed the drawing of these pencils in water (see page 122), use Indigo Blue, Sepia and Warm Grey 50% to complete the rim, some of the raised ribs, and the reflection in the edge of the water. These colors combine to represent the tint of the vase and the color from the pencils.

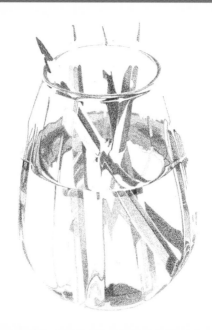
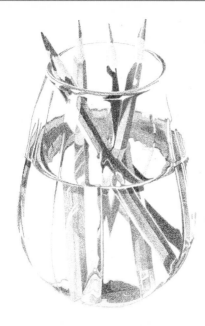

3 ADD MORE COLOR

Begin to layer colors to establish the local color of each pencil.

Pencil 1—Top half: Dark Umber and Indigo Blue. Bottom half: Parma Violet.

Pencil 2—Use Dark Umber, Peacock Blue, Dark Green and Deco Blue as shown.

Pencil 3—Use Peacock Blue and Light Aqua on the bottom and Peacock Green on the top. Gold cap: Reapply Sepia and Light Umber.

Pencil 4—On the top and bottom use Peacock Green and Dark Green. Use Light Green on the bottom only.

Pencil 5—Color the top with Indigo Blue.

Pencil 6—Color the bottom with Black Grape and color the top with Dark Umber.

2 BEGIN THE PENCILS

Pencil 1—Use Black Grape to color the lead and the parts as shown.

Pencil 2—Start to define the pencil with Indigo Blue and Peacock Blue.

Pencil 3—Color Sepia on the bottom half. Use Black Grape and Dark Umber on the top half. Gold cap: Sepia and Light Umber.

Pencil 4—Use Dark Green on the bottom half and Indigo Blue for the top.

Pencil 5—Color the pencil lead Indigo Blue.

Pencil 6—Color the lead with Indigo Blue and the bottom half of the pencil with Dark Umber.

4 FINISH THE DRAWING

Add more color to all the pencils. Fill in the paper tooth by using a sharp tip and increasing pressure. Complete the shadow cast by the vase.

Pencil 1—Add Parma Violet and Violet to the entire pencil including the lead.

Pencil 2—Color the entire pencil and lead with Deco Blue.

Pencil 3—Repeat all colors to darken and fill in. Gold cap: Add Goldenrod.

Pencil 4—Use Deco Aqua over the darker parts of the pencil and Light Green over the rest.

Pencil 5—Complete the pencil with Indigo Blue and True Blue.

Pencil 6—Use Indigo Blue over the entire pencil.

The Wood—Color all the wood with Burnt Ochre (lighter pressure toward the light source); then add Dark Umber and Parma Violet to the dark side and Jasmine to the lighter side.

Cast Shadow—Use a combination of State Grey and Light Umber to complete the shadow. Add Indigo Blue as shown, near the vase.

Vase—Reapply the Indigo Blue, Sepia and Warm Grey 50% and then use Deco Blue to lightly tint the water.

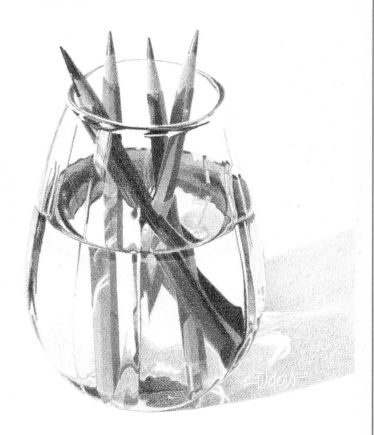

WHAT HAPPENS WHEN TRANSPARENT COLORS OVERLAP?

materials list

Surface
Fabriano Uno HP
140-lb. (300gsm)

Pencils
Ultramarine (PC)
Hot Pink
Deco Blue
Lemon Yellow
Dark Magenta (PC)
Greyed Lavender

Light Blue (PC)
Aquamarine
Dahlia Purple
Ultramarine
Bronze
Peacock Blue

Other
Kneaded eraser or
reusable adhe-
sive

When one transparent layer of color overlaps another color, the area of overlap is a combination of the two colors. If one color is dark and the other is light, keep values the same and layer one color over the other. If a colored transparency overlaps itself, the area of overlap is a darker value of that color.

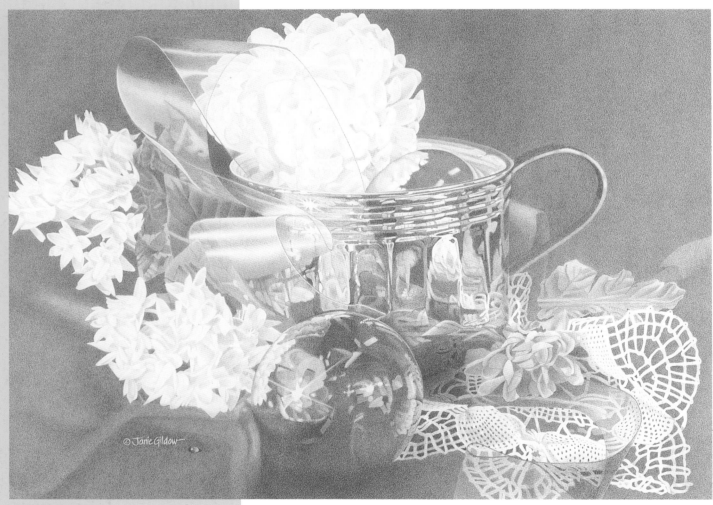

BROKEN PROMISE
Janie Gildow
Colored pencil on Strathmore Bristol 500 Plate 3-ply
13½" × 18½" (34cm × 47cm)
Private collection

Reapplied
Hot Pink

Reapplied
Ultramarine
(PC)

Hot Pink over
Ultramarine (PC)

Lemon
Yellow over
Deco Blue

Ultramarine (PC)

Dark Magenta

Dark
Magenta
over
Ultramarine
(PC)

Deco Blue

1 BEGIN TO DEFINE THE COLOR AREAS

Once you've drawn in these cellophane curls (see page 122), apply Ultramarine (PC) to the curl on the left. Then apply Hot Pink. Reapply the Hot Pink for double color where the pink cellophane overlaps itself. Begin the curl on the right with Deco Blue.

2 CREATE MORE OVERLAPS AND ADD MORE COLOR

Continue to add Deco Blue to the right-hand curl; then add Lemon Yellow. Where the yellow cellophane overlaps the blue, apply yellow over the blue. Go back to the curl on the left and apply more Hot Pink. Where the pink cellophane overlaps the blue, color Hot Pink right over the already applied Ultramarine (PC).

3 STRENGTHEN THE COLOR

Apply Dark Magenta to the areas where the pink cellophane overlaps itself on the left curl, and Ultramarine (PC) where the blue overlaps. Adding more color continues to create the illusion of transparency. Add Deco Blue to the right curl.

Light Blue and
Aquamarine

Greyed
Lavender

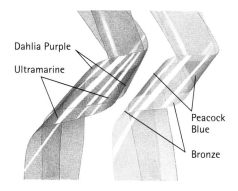

Dahlia Purple

Ultramarine

Peacock
Blue

Bronze

4 STRENGTHEN THE COLOR OF THE CURL ON THE RIGHT

Add more Lemon Yellow where the yellow cellophane overlaps itself. To darken the yellow where it is in shadow, use Greyed Lavender. Darken the blue with a combination of Light Blue and Aquamarine.

5 GIVE IT PIZZAZZ

Now you need to punch up the contrast. Go back into the drawing and darken the edges of the cellophane. Use Dahlia Purple and Ultramarine on the left curl. Use Bronze and Peacock Blue on the curl on the right.

Use these same colors where several layers of cellophane overlap and on the sides of each curl to give it depth. The top of the curl's arch should be left lighter. Keep the edges of the highlights sharp and crisp. Use a kneaded eraser or reusable adhesive and lift color to keep the highlights white.

WHAT HAPPENS IN A MIRROR REFLECTION?

PERSPECTIVE IN A MIRROR
Notice that the sides of the real bottle and the reflected bottle seem to converge toward the bottom of the picture. They share the same vanishing point (outside the bottom of the picture). The top and bottom edges of the rectangular bottle and its reflection all use either the right or the left vanishing points. Place a ruler on the sides and edges of the bottle to see how the lines converge to the shared points.

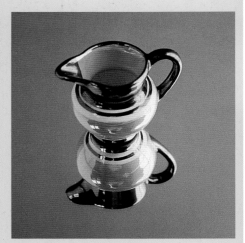

ELLIPSES IN A MIRROR
An object and its reflection are affected by depth so that the reflected pitcher seems to get smaller toward the bottom of the picture. Lines drawn to the vanishing points determine the axes of the ellipses that make up the pitcher. The reflected view is upside down and shows more of the underside of the pitcher.

Reproducing what happens in a mirror may seem difficult or confusing at first, but the most important thing to remember is that the mirror is just like a window. You look through (or into) it and merely see another scene. The easy part is that the scene in the mirror uses all the same colors of the actual objects and background. The view into the mirror consists of the actual objects seen from a different angle—and upside down.

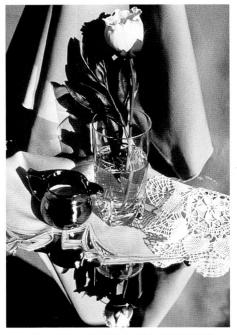

USING A MIRROR IN A COMPOSITION
A mirror image provides a unifying element to a composition.

If you are familiar with linear perspective, notice that the mirror objects share the same vanishing points with the actual objects because your eye level determines those vanishing points. The scene appears upside down, but is not an exact symmetrical image of the real objects. You will see a portion of the bottom of any object that sits on the mirror, and you will feel as though you are looking up at it.

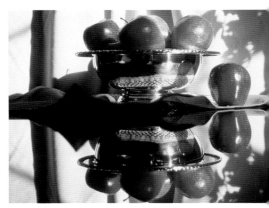

ALMOST SYMMETRICAL
As your eye level approaches mirror surface level, the view of the objects and their reflections becomes more and more symmetrical. Here, eye level is a little below the lip of the silver bowl. Notice how much of the underneath side of the lip you can see in the reflection. The view of objects in a mirror will never be exactly symmetrical.

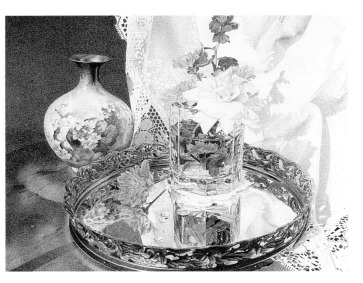

Without any other visual clues, you know the objects here are on a mirror.

LACE REFLECTIONS
Janie Gildow
Colored pencil on
Crescent 115 Hot Press
14.5" × 17.5"
Collection of the artist

HOW CAN I CREATE A REALISTIC DROP OF WATER?

Water drops are fun and easy. If you observe actual water drops on a surface, you will find that they are many different shapes. If you try to recreate each and every one, you will not only confuse your viewer, but you may end up outdoing yourself. In this demonstration, less is more. Use drops sparingly and they will have greater impact.

There are several things to watch for when making a realistic drop:

1. The drop is made of the colors of the surface on which it rests.

2. The outline of the drop is darker than the surrounding surface color.

3. There is always a sparkle of light (the reflection of the light source), and it is always located in the darkest part of the drop.

4. The dark part of the drop gradually lightens in the direction away from the white sparkle.

5. The lightest part of the drop (other than the sparkle) is actually lighter than the surface on which it rests.

6. The drop itself casts a shadow onto the surface beside it. The shadow is always located just outside the lightest part of the drop.

When the drop rests on a white ground, you need to use colors that usually represent water, even though the water itself really has no color of its own. You can use gray if you want, but it's more fun to use "water" colors.

DROP ON PENCILED BACKGROUND
This drop is composed of the colors added to the background (Black Grape and Henna). Outline the drop with Black Grape and add Black Grape to the cast shadow and to render the drop's values. Layer Henna over the entire drop, reducing pressure near the cast shadow. Keep the part of the drop nearest the cast shadow lighter in value than the background color. Save the white of the paper for the sparkle.

DROP ON COLORED SURFACE
The values and shadow are established with Slate Grey. Add Deco Blue and Jade Green to simulate the color of the background. When you draw a drop on an already colored ground, use a white pencil to add the sparkle and use some white (or a lighter value) pencil inside the drop nearest the cast shadow to magnify the light within the drop.

demonstration | **drop of water**

1 DRAW THE DROP AND CAST SHADOW
Keep the outline of the drop oval, rather than irregular.

2 ADD COLOR TO THE CAST SHADOW
Use Slate Grey to establish the shadow's value. Use a light touch; you just want to give the impression of colorless water on a white ground.

3 COLOR THE DROP
Continue to use Slate Grey to color around the sparkle. As you work back toward the cast shadow, gradually and smoothly reduce pencil pressure. Leave the area closest to the cast shadow white. The Slate Grey establishes both the color foundation and the value for the local color.

4 COMPLETE THE DROP
Use Periwinkle, Celadon Green and Deco Blue and layer each in the same manner over the Slate Grey. The combination of these colors completes the local color of the water. Reduce pencil pressure toward the saved white. You can extend the Deco Blue a little farther into the white area, but don't cover all the white. Remember to use a light pressure since you just want to give the impression of water on a white surface—and water really has no color.

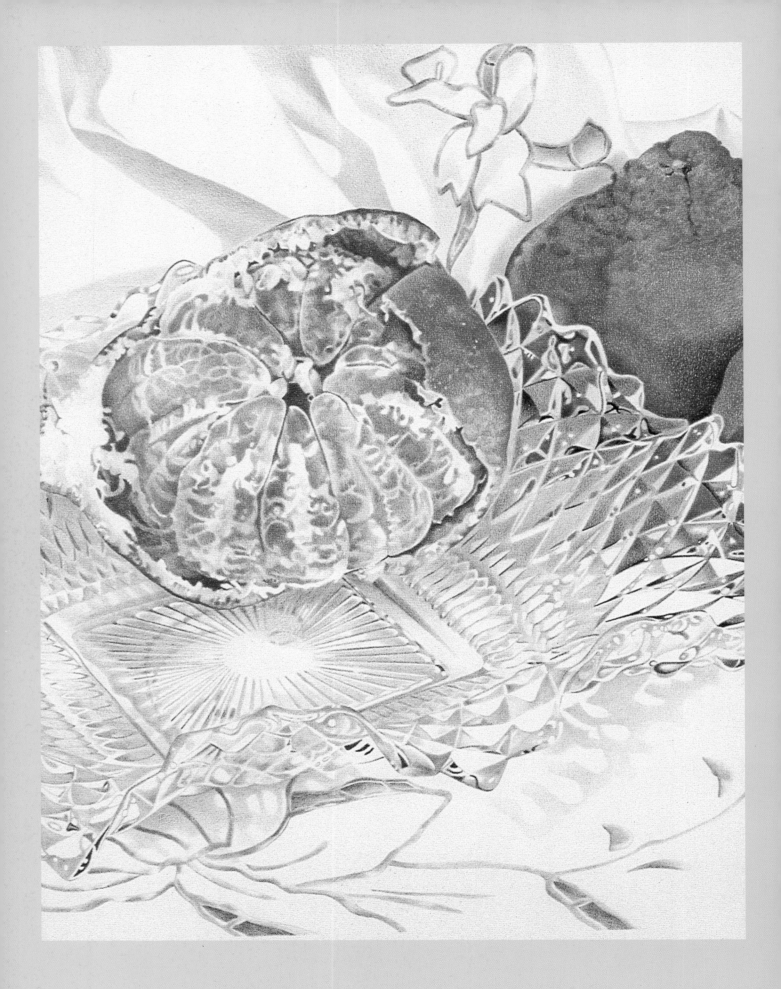

6 texture solutions

In this chapter you'll learn how to reproduce textures. You'll see how light affects different surfaces and find out how to apply color to reproduce those surfaces. Learn to create the look of slippery satin, velour peaches, waxy peppers, velvet rose petals and more!

Creating different textures involves seeing and reproducing changes in value. Abrupt changes. Gradual changes. And it requires smooth pencil application.

Smooth velvety textures capture light evenly. Shiny surfaces flaunt a greater range of values, from their harder-edged bright white highlights to their dark shadows. Bumpy and uneven surfaces boast a series of hills and valleys that break up light and create patterns. Fuzzy surfaces don't have any sharp highlights; their range of values is more limited.

Color goes hand in hand with texture, adding another dimension: the delicate pink of a sweet pea, the glow of a sun-drenched peach, the flamboyant blast of a butterscotch daylily, elegant ice-blue satin. Read on. Experience texture.

DEBUT: SATSUMAS (DETAIL)
Barbara Benedetti Newton
Colored pencil on Strathmore 500 Bristol Plate
19½" × 18¾" (50cm × 48cm)
Collection of Gary Haight

HOW DO I MAKE SHINY SATIN FABRIC?

materials list

Surface
Fabriano Uno HP 140-lb. (300gsm)

Pencils
Delft Blue (PC)
Ultramarine
Blue Slate

The secret to making shiny slick fabric, like this satin, is in rendering the smooth, gradual changes from light to dark. Shiny fabric exhibits a much greater range of values from dark to light than nonshiny material does; its darks are darker and its lights are lighter. Abrupt changes in value happen along an edge or where the material overlaps. Where the fabric casts its own shadow, the shadow's edge can range from sharp to soft and blurred. All changes in contour are even and gradual. The shapes of the white highlights are well defined—in some cases, nearly sharp-edged. That's what makes the fabric look shiny.

demonstration | **shiny satin**

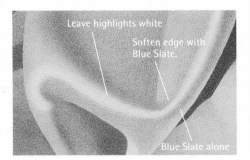

1 ESTABLISH THE VALUES

After drawing a piece of fabric (see page 123 for full view of fabric as seen below), use Delft Blue to make a nearly complete value study. Where values change gradually, layer smoothly and evenly. Color full-value in the darkest areas and keep the edges sharp and clean. Define the highlights, but keep their edges soft. Use an extremely light touch for the lightest values. When you finish this step, the fabric should look shiny and nearly complete.

2 ADD MORE COLOR

Layer Ultramarine over the middle to dark values but not over the lighter values. Apply it evenly over the Delft Blue and in the same manner. All you want to do at this point is to add some depth of color to the already established values.

3 COMPLETE THE LOCAL COLOR

Layer Blue Slate over all the already applied color to complete the local color mix. In addition, use it alone for some of the highest values. Use it to soften edges and to smooth any uneven areas.

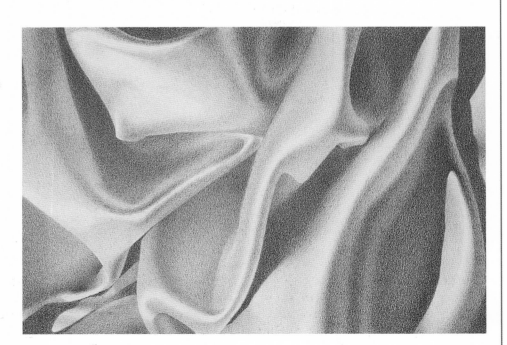

FULL VIEW OF FABRIC

WHAT CREATES THE LOOK OF COARSE LINEN?

When we think of the graceful, fluid contours of supple fabric, it may remind us of rolling hills. Stiff linen fabric, with its plentiful creases and wrinkles, can be thought of as craggy, jagged mountain ranges. Value changes are abrupt. The places where strong shadows and bright highlights meet are well-defined ridges.

materials list

Surface
Rising Stonehenge White

Pencils
French Grey 50%
Black
Indigo Blue
Salmon Pink

demonstration | **coarse linen**

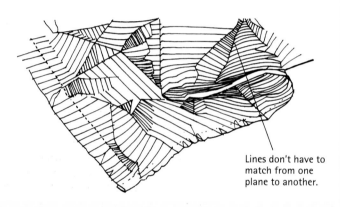

1 CONTOUR DRAWING
Even if you're working from reference photos, you should familiarize yourself with the form of the fabric. Complete a contour sketch to understand how the different planes of fabric are arranged and juxtaposed. Make lines close together to indicate darker areas.

Lines don't have to match from one plane to another.

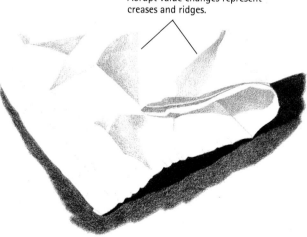

Abrupt value changes represent creases and ridges.

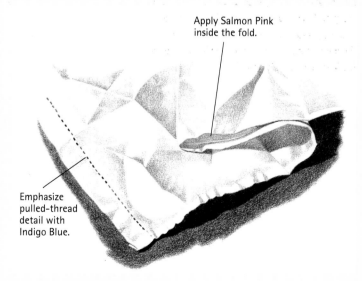

Apply Salmon Pink inside the fold.

Emphasize pulled-thread detail with Indigo Blue.

2 BLOCK IN LARGE AREAS
After completing a final sketch of this piece of fabric (see page 123), apply French Grey 50% in a range of values to indicate where major planes and shadows are. Use Black and Indigo Blue to color the surface under the linen fabric.

3 DETAIL AND COLOR
Lightly apply Indigo Blue and Salmon Pink over the French Grey 50%. Add subtle dents and wrinkles as needed with the same two colors.

HOW DO I CREATE THE BUMPY SURFACE OF INDIAN CORN?

COMPLETED EAR OF CORN

The combination of kernel color and pattern combined with an artful arrangement of the husks makes Indian corn a great subject to include in your composition.

The kernels are distinguished one from another by value, color and/or shape. This ear of corn contains kernels of three different local colors: blue, red and yellow. Each local color consists of three layered colors. Kernels are usually darker around the edge than they are in the center, so as you color them, use heavier pencil pressure around the edge and gradually decrease pressure as you move toward the highlight.

materials list

Surface
Fabriano Uno HP
 140-lb. (300gsm)

Pencils
Black Grape
Tuscan Red

Greyed Lavender
Indigo Blue
Marine Green
Goldenrod
Bronze
Deco Yellow

demonstration | indian corn kernels

1 SET VALUES

After completing a sketch of an ear of corn (see page 123), use your base colors to outline the kernels and then fill them in to establish their values. Leave the highlight white.

Use Black Grape for the blue kernels, Tuscan Red for the red kernels and Grayed Lavender for the yellow kernels.

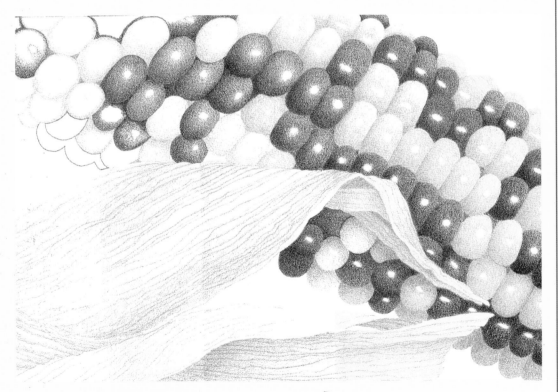

2 DEVELOP LOCAL COLOR

Layer local colors right over the values. Add a layer of Indigo Blue to the blue kernels. Add Marine Green to mellow the red kernels, and add Goldenrod to warm the yellow kernels.

3 FINISH THE KERNELS

Finish the blue kernels with a layer of Marine Green to give warmth. A layer of Bronze will warm up the red kernels. Add a layer of Deco Yellow on the yellow kernels to help give those kernels depth. Repeat steps two and three as needed to increase color and value.

HOW DO I CREATE THE SMOOTH, WAXY SURFACE OF PEPPERS?

Peppers have a depth of rich color different from any other vegetable. They have a waxy skin that catches the light, making bright white highlights. The brightest highlights will be hard-edged, but many of the lesser ones will have softer edges that blend gradually into the pepper's sumptuous local color.

The yellow pepper is light in value, so its shadows won't be very dark. Its local color should be rich, sunny yellow with hints of gold. The shadows should be less intense (duller).

The green pepper is deep and colorful and contains the darkest shadows of the three. Its surface should look as though it's several inches deep, giving the impression that you can look down into it.

The red pepper is very nearly the same value as the green pepper. Its shadows aren't quite as dark as the shadows on the green pepper, but its local color is deep and intense. It can be more difficult to achieve a good red local color than it is to achieve a green or a yellow. Keep the local color mix warm.

materials list

Surface	Grass Green
Fabriano Uno HP	Chartreuse
140-lb. (300gsm)	Scarlet Lake

Pencils | **Red Pepper**
Yellow Pepper | Dark Purple
Burnt Ochre | Process Red
Periwinkle | Orange
Goldenrod | Grass Green
Yellowed Orange | Crimson Red
Deco Yellow | Scarlet Lake
Sunburst Yellow |

	Stems
Green Pepper	Black Grape
Black Grape	Henna
Tuscan Red	Dark Green
Celadon Green	Grass Green
Dark Green	Limepeel
Yellowed Orange	

demonstration | peppers

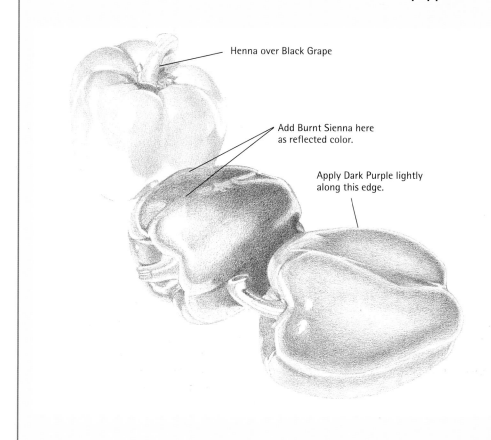

Henna over Black Grape

Add Burnt Sienna here as reflected color.

Apply Dark Purple lightly along this edge.

1 BEGIN TO DEVELOP THE LIGHTS AND DARKS

Yellow Pepper—After sketching in these peppers (see page 124), begin applying Burnt Ochre and use a very light touch. Remember that the yellow pepper is extremely light in value, and that means that its shadows will be high in value, too. Increase pressure in the darker areas. Add some Burnt Ochre to the green pepper as reflected color from the yellow pepper.

Green Pepper—Establish the darks with Black Grape. Increase pressure in the darker areas for more complete coverage and make smooth, gradual changes as you move toward the lighter areas.

Red Pepper—The red pepper is nearly as dark in value as the green pepper. Dark Purple establishes the value.

Stems—Lightly apply Black Grape, then apply Henna right over it. Increase pressure (with both colors) where values are darker.

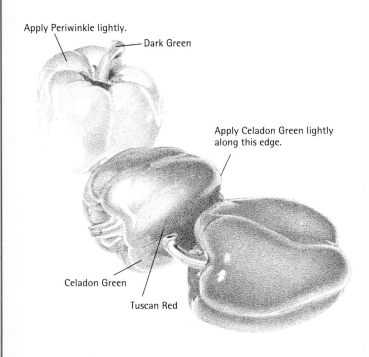

Apply Periwinkle lightly.

Dark Green

Apply Celadon Green lightly along this edge.

Celadon Green

Tuscan Red

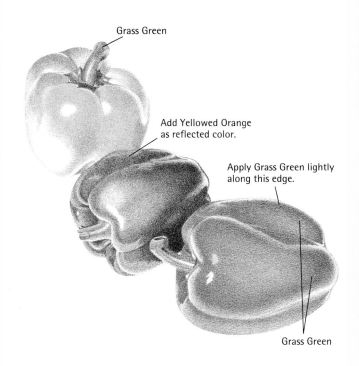

Grass Green

Add Yellowed Orange as reflected color.

Apply Grass Green lightly along this edge.

Grass Green

2 CONTINUE TO ADD COLOR

Yellow Pepper—Add Periwinkle (complement of Burnt Ochre) to the shadows. Don't add any Periwinkle at all to the lightest areas.

Green Pepper—Over the darkest parts of the Black Grape, apply Tuscan Red as the complement and to warm the green that you will apply later. In addition, layer Celadon Green where the lightest values of green will be—next to the whitest highlights and in areas of reflected light. For the edges of the green pepper, you'll create the gray with Celadon Green over the Black Grape.

Red Pepper—Using a light pencil pressure, color the entire pepper Process Red. Color right over the Dark Purple, increasing pressure over the darker areas. Don't color over the white highlights, but color everywhere else.

Stems—Add Dark Green as the first step in establishing the local color mix.

3 ADD MORE COLOR

Yellow Pepper—Begin to develop the rich golden color of the pepper. First apply Goldenrod, then over it apply Yellowed Orange. Leave the lower left side of the pepper white.

Green Pepper—Now you can begin to make the pepper look green. Use Dark Green and color over everything but the lightest highlights. Allow the reflected red to show through the Dark Green on the side nearest the red pepper. Add some Yellowed Orange over the Burnt Ochre as reflected color on the side nearest the yellow pepper.

Red Pepper—Apply Orange to the entire pepper—all except the highlights. Be sure to apply enough to warm the Dark Purple and Process Red. To the shadowed areas, lightly apply some Grass Green. Don't add enough to make the pepper look green—just enough to tone down and cool the shadows.

Stems—Add Grass Green to the stems, coloring everywhere except over the lightest values.

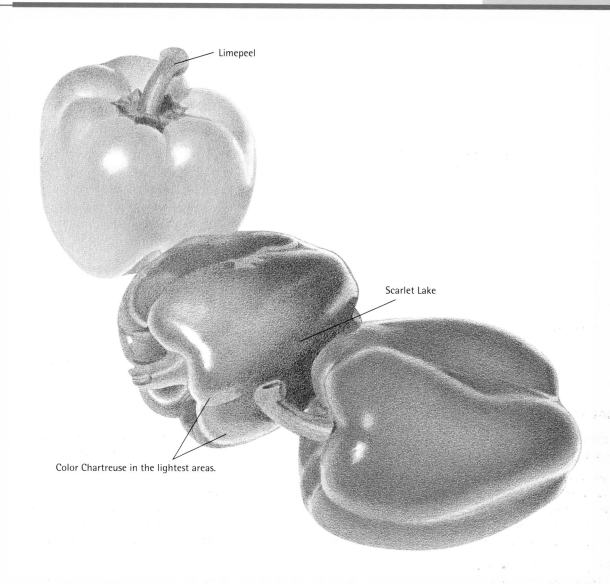

Limepeel

Scarlet Lake

Color Chartreuse in the lightest areas.

4 FINISH THE PEPPERS

Yellow Pepper—Complete the pepper by adding the sunny yellows. First, color over the lower left side with Deco Yellow. Then color the entire pepper with Sunburst Yellow. The pepper should look bright and warm.

Green Pepper—First, apply Grass Green to the entire pepper except for the lightest edges and highlights. Then to the warmest and lightest parts of the pepper, apply Chartreuse. Work the Chartreuse down into the paper tooth. It needs to show over the already applied darker greens. Add Scarlet Lake to the right side as reflected color.

Red Pepper—Finish the red pepper with a mix of Crimson Red and Scarlet Lake. First apply the Crimson Red to the entire pepper (except the highlights). Then apply Scarlet Lake in exactly the same way.

Stems—Apply Limepeel to the entire stem. Color lightly over the white highlights; the stems aren't shiny.

HOW CAN I MAKE THE SMOOTH, SHINY SURFACE OF A PLUM?

materials list

Surface
 Rising Stonehenge
 White

Pencils
 Straw Yellow (DA)
 Burnt Carmine
 (DA)

Black Grape
Crimson Red
Indigo Blue

Other
 Tracing paper or
 Frisk Film
 Fine-point pen

When you make shiny, smooth fruit, it isn't necessary to use a heavy application of pigment. A consistent application of colored pencil can achieve the look. Use a sharp tip and a light touch. The play of light and shadow as well as coloration also helps an object read as shiny or smooth.

demonstration | plums

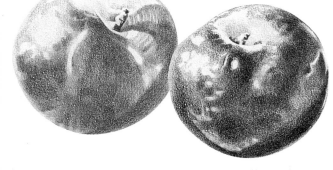

1 MAKE YELLOW SPECKS

Complete a drawing of these plums (see page 124). Both of the plums have tiny yellow specks that help define the character of the fruit. To make these small dots, apply a light layer of Straw Yellow where needed, then use the impressed-line technique. Place a piece of tracing paper or Frisk Film over the area where the specks will be and poke the drawing with a fine pen point to make craters in the surface of the paper that will show up as plum specks as other colors are layered on top.

2 ADD THE FOUNDATION COLOR

The red plum on the left has a foundation color of Burnt Carmine. The black plum foundation color is Black Grape. Use varying pressure and layers of color. Color over but not into the impressed specks and over the yellow foundation. To make areas as dark and solid as possible, sharpen the pencils and apply color to any texture of white paper showing through the color.

Leave highlights uncolored.

Apply Indigo Blue lightly around the stem for the haze that appears on some plums.

3 ADD THE LOCAL COLOR

For the red plum, use Crimson Red in an overall application except on the highlights and yellow areas. Reapply Straw Yellow to brighten any exposed yellow areas. To darken areas, add Burnt Carmine. Complete the local color of the black plum with layers of Burnt Carmine, Crimson Red and Indigo Blue.

HOW DO I PORTRAY THE FUZZY TEXTURE OF A PEACH?

Working with the texture of your paper can help you achieve a soft, fuzzy surface like this peach. The application of pigment should be light, allowing the tooth of the white paper to show through the applied color.

materials list

Surface
Rising Stonehenge White

Pencils
Mahogany Red
Mineral Orange

Straw Yellow (DA)
Pale Vermilion
Pink
Indigo Blue

Other
Reusable adhesive

demonstration | peach

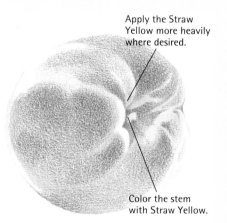

Apply the Straw Yellow more heavily where desired.

Color the stem with Straw Yellow.

1 FORM THE PEACH
After drawing this peach (see page 124), build the form and volume of the peach with Mahogany Red. Use light, circular strokes with a sharp tip and let the texture of the paper show through the color to make the peach look fuzzy. Vary pressure and number of layers as needed for value.

2 ADD LOCAL COLOR
With Mineral Orange, use light, loose circular strokes over the Mahogany Red to establish the overall local color of the peach. The loose strokes will allow the previously established texture to show through. There is no need to mix the two colors completely, the viewer's eye will do it.

3 ADD A YELLOW GLOW
Use Straw Yellow in the lightest areas and to enhance the built color. Leave areas of pure white paper as the strongest highlights or for very soft color.

Soften edges by lifting color with reusable adhesive.

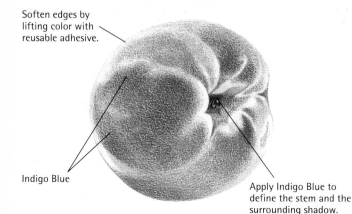

Indigo Blue

Apply Indigo Blue to define the stem and the surrounding shadow.

4 BRING ON THE COLOR
Punch up your peach with Pale Vermilion and Pink. These colors enliven the local color you have established. Use a light dusting of Indigo Blue in selected areas to portray the absorption of light into the dense velvet texture of the peach skin.

WHAT CREATES THE LOOK OF A VELVETY ROSE?

materials list

Surface
 Rising Stonehenge
 White

Pencils
 Pale Geranium
 Lake (PC)
 Vermilion (PC)

Sea Green (PC)
Dark Magenta (PC)
Orange Yellow (PC)
Apple Green (PC)

Other
 Reusable adhesive

Velvety textures, like the petals of a rose, can be achieved through layers of color and value. Applying color in patches, rather than a smooth layer of color, adds to the appearance of the "velvet."

demonstration | rose

1 COLOR FOR IMPACT

After drawing this rose (see page 124), use a sharp point and light touch to apply Pale Geranium Lake to the darkest areas and the midtone areas to capture the drama of the play of light on the rose. Use heavier pressure and more layers for darkness. Lighten where necessary by lifting color with reusable adhesive.

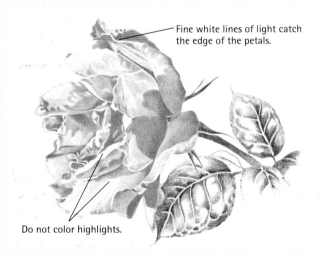

Fine white lines of light catch the edge of the petals.

Do not color highlights.

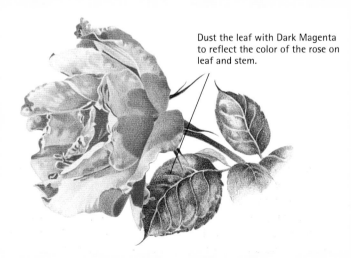

Dust the leaf with Dark Magenta to reflect the color of the rose on leaf and stem.

2 FORM THE PETALS, STEMS AND LEAVES

Apply Vermilion with medium pressure over the darkest areas, and more lightly where there is midtone foundation. Color each petal, except where there are strong highlights. To render the texture of the petal, apply Vermilion in patches rather than a consistent field of color.

Lay in foundation on stems, bracts and leaves with Sea Green. Vary the pressure and number of layers to get a range of value to form each leaf. Leave white paper to portray veins in leaves.

3 ADD INTEREST AND DEFINITION

Use Dark Magenta to make the existing colors more intense. Layer Orange Yellow to add transparency to the highlighted areas and petal edges, and a sunny warmth to darker areas. Apply Pale Geranium Lake on top of Dark Magenta to soften the abrupt color change if needed.

Apply Apple Green on top of the Sea Green in the leaves and stems, except in highlighted areas. Vary the pressure and number of layers to get a range of value. The topmost layer can be another application of Sea Green to darken selected areas.

HOW DO I MAKE CLUSTERED FLOWERS?

A cluster flower at first appears complex, but it is simply many individual flowers growing closely together. Forms are basically the same but arranged so they are viewed at different angles.

materials list

Surface
Rising Stonehenge White

Pencils
Deep Cobalt Blue (PC)

Dark Magenta (PC)
Cedar Green (PC)
Pale Geranium Lake (PC)
Canary Yellow (PC)
Van-Dyck-Brown (PC)

demonstration | **sweet pea**

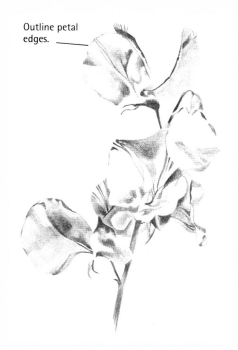

Outline petal edges.

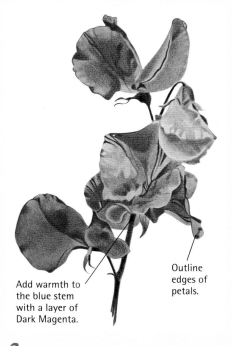

Add warmth to the blue stem with a layer of Dark Magenta.

Outline edges of petals.

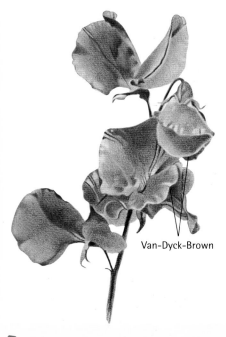

Van-Dyck-Brown

1 A BLUE FOUNDATION
After sketching in this sweet pea plant (see page 125), create the form and volume with Deep Cobalt Blue. Vary the range of value from very light (one lightly applied layer) to very dark (several layers and increased pressure). Leave the lightest areas uncolored and do not apply blue where you plan to put yellow because you'll get green.

2 ADD WARMTH
Apply Dark Magenta heavily over areas of dark blue to create violet. Where applied lightly, the Dark Magenta will allow Deep Cobalt Blue to show through. The texture on the petals is created by making patches of color instead of one even layer. Add Cedar Green to the stems, leaving areas uncolored where you will add yellow.

3 FINISH WITH LIVELY COLORS
Use Pale Geranium Lake and Canary Yellow within the petals as needed to warm and highlight areas. Differences in value and temperature help separate the petals from one another. Cool colors recede (Deep Cobalt Blue) and warm colors advance (Pale Geranium Lake). Deepen value as needed with some Van-Dyck-Brown.

HOW DO I PORTRAY THE WARMTH OF A DAYLILY?

The daylily is a yellow trumpet-shaped flower. Down into the throat and wherever the petals are in shadow, its color deepens to butterscotch and rust. The rust appears on the blossom pods where it is mixed with some of the same greens that make up the leaves and stems. Laying color over grisaille work gives the depth and warmth of the daylily's color and texture.

demonstration | **daylily**

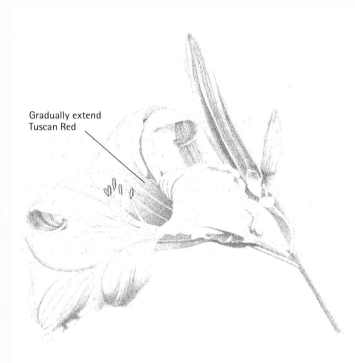

Gradually extend
Tuscan Red

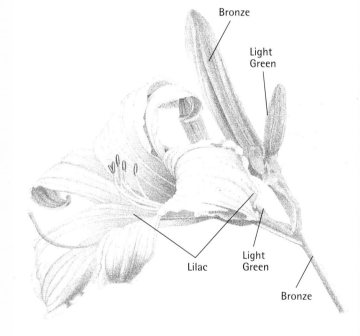

Bronze

Light Green

Lilac

Light Green

Bronze

1 DARKEST VALUES

After sketching in this daylily (see page 125), use Imperial Violet for the darkest parts of the leaves and stems and where the flower petals and buds are the darkest. Then layer Tuscan Red over the Imperial Violet on the flower and the buds. Extend the Tuscan Red beyond the violet in some areas. Apply just the Imperial Violet to the leaves and the stems.

2 APPLY LIGHTER VALUES

Define the lighter shadows on the flower petals with Lilac. Increase pressure where the shadows are darker and decrease pressure in lighter areas. Leave the lightest parts of the petals the white of the paper.

The larger buds combine the rich rust color from the darkest part of the blossom with the greens of the leaves and stems. Layer Bronze over the Imperial Violet. Extend it past the violet on the stems and use it alone on the smaller buds. Then use Light Green to color the edges and tips of the buds. Use Light Green to highlight the tips of the leaves and the smaller stems.

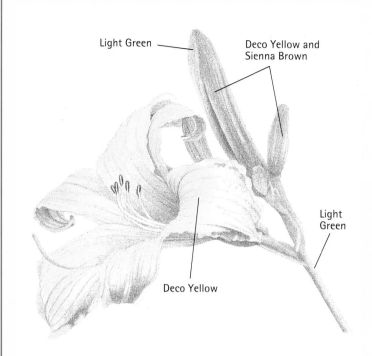

Light Green

Deco Yellow and
Sienna Brown

Light
Green

Deco Yellow

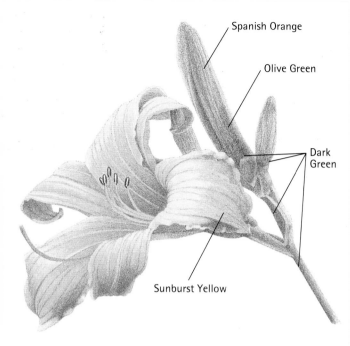

Spanish Orange

Olive Green

Dark
Green

Sunburst Yellow

3 HIGHLIGHTS

Apply Deco Yellow to the lightest parts of the petals, right up to the Lilac, then blend it just barely into the Lilac.

Use Deco Yellow to warm the centers of the two largest buds. Then use Sienna Brown over the yellow. Add another layer of Light Green to the tips and outside edges of the buds and to the stems and leaves.

4 ADD LOCAL COLOR

Use Sunburst Yellow to color over the entire flower, except for the lightest parts. Because you have already established the shadows and the base for the local color, just this one color is enough to complete the flower.

Use Spanish Orange to color over the already applied values on the buds. Don't color over the Light Green, just color up to it. To further enrich the bud color, apply a layer of Olive Green to the darker parts of the buds.

Layer Dark Green over the darker parts of the stems and leaves. The dark value emphasizes the shadows. Add some Dark Green to the bottom portion of the large bud for more contrast.

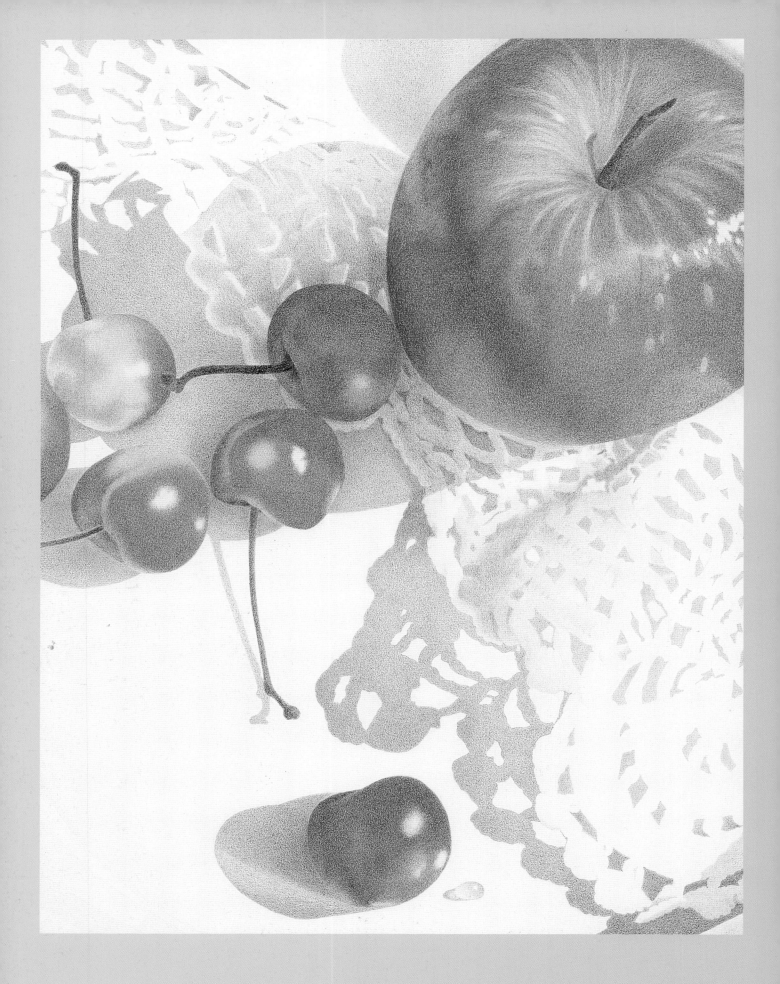

7
problem subjects and fixing mistakes

This chapter teaches you how to deal with problems and helps you approach difficult subjects with confidence.

Learn that all is not lost when you make a mistake. Most mistakes can be corrected, but the secret lies in not making them in the first place! The more slowly you work, the less likely you are to make irreparable mistakes, because you can see the mistake begin to develop. The one most important thing you can do once you realize you may have made a mistake is to *stop* what you are doing and evaluate the situation. If you keep working, oftentimes you'll just compound the problem and make it more and more difficult to fix. But mistakes happen. And when they do, this chapter shows you how to fix them.

What about those pesky complicated subjects? Can you simplify lace? What about spaghetti fringe? And what happens with a woven basket or a striped sleeve? All of them are just repeating patterns affected by changes in contour or arrangement. Once you get down to the basics and learn what to look for, it's much easier to see and reproduce those changes.

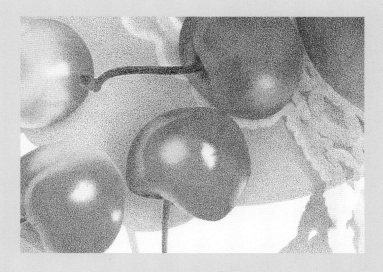

SERENDIPITY (DETAIL)
Janie Gildow
Colored pencil on Fabriano Uno HP 140-lb. (300gsm)
12" × 16½" (30cm × 42cm)
Collection of the artist

HOW CAN I FIX THESE COMMON MISTAKES?

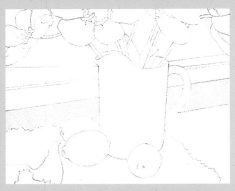

Sometimes color looks flat and uninteresting.

Color becomes more interesting when it is gradated.

Bouncing tones slightly with juxtaposed colors adds punch.

Adding texture or pattern gives color energy.

How Do I Punch up Color?

Apply the shape's complementary color to the surrounding area. It will make the shape appear brighter and more vivid.

How Do I Make an Area Less Prominent?

If an outline or shape is too obvious, usually it's because there is too much contrast between it and the area next to it. To reduce contrast and bring the two values closer together, select a middle-value color and lightly layer it over both areas. Sometimes prominence results from too much color intensity. To neutralize a bright color, apply its complement over it.

How Do I Straighten an Edge?

Sometimes your work contains straight edges. To avoid the look of a technical drawing, it is usually best not to draw straight lines. Instead, color up to or away from a straight-edged photograph or other stiff paper.

To apply color up to a straight edge, place a piece of paper so that it coincides with the straight line. Color up to and against the edge of the paper. The paper protects the adjacent area and keeps it free from color.

To apply color away from a straight edge, align the paper in the same manner. Start the stroke on the paper; continue it across the edge and onto your drawing surface.

With either method you will produce a clean, straight edge without drawing a hard defining line. Try using an erasing shield (see page 19) if a line needs to be cleaned up.

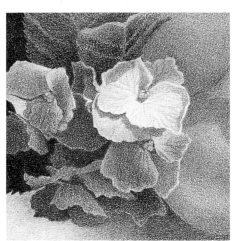

EVALUATE THE COMPOSITION

The blossom on the left is too prominent; it steals some of the impact from the focal point (the nearly white blossom). The orange persimmons are too bright and seem to jump forward. They should recede more into the background, but at the same time still need to retain some of their orangeness.

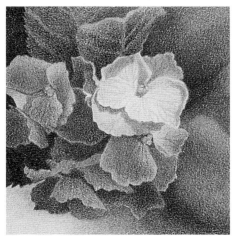

ADJUST VALUE AND INTENSITY

Color over the prominent blossom with a medium-value color (in this case, Blue Violet Lake) to lower the value of the blossom and reduce the contrast between it and the area around it.

To lower the value of the persimmons, deepen their color (bottom persimmon, Tuscan Red; top persimmon, Dark Purple). To reduce the intensity of the local color, choose a near complement (in this case, Violet Blue) and color over the entire persimmon. Increase pressure to darken the value of the top persimmon even further. Now the persimmons recede into the background. They are still orange, but a lower-value and less-intense orange. They don't compete with the light blossom for attention.

How Do I Repair Paper Damage?

DENTS OR NICKS—If you find dents or nicks in your white paper, fill them in with color, colorless blender or white pencil. For colored paper, fill the nick with the pencil color that matches best.

HOLES—These are difficult to hide. First find a scrap of the surface you are using and cut a small piece of it (about a half-inch [13mm] larger than the hole). Color it exactly like the area around the hole. Attach it to the back of the drawing (behind the hole) with archival glue and secure the edges with archival-quality tape. Once you attach the piece, don't color over the hole again. Pigment will catch around the edge, making it darker and more obvious.

How Do I Deal With a Tiny Area That Gets Too Dark?

Sometimes as you layer, a small spot quickly develops more color than its surroundings. The dot usually isn't the problem; instead the surrounding area is probably too light.

What Do I Do When Little Blobs of Pigment Develop?

As you apply color, bits of pigment can catch on tiny uneven areas, or even on built-up color. Carefully remove the little blob with the tip of a sharp art blade. Be careful not to dig down into the paper; lightly scrape just the little dot of color. Then wipe the blade.

Another method is to twist reusable adhesive into a tiny point. Use a light dabbing motion to remove the blob. Repeat with a clean twist.

If you find blobs of color to be a recurring problem, try a sharper tip, lighter touch, different stroke or different paper.

What Do I Do When No More Pigment Will Stick?

If you need to add just a little color, spray the heavily pigmented area with workable fixative, then lightly apply more color.

If you find you are having a recurring problem getting as much pigment as you want to stick to the paper, try changing to a paper with more texture (tooth).

Can I Alter the Surface of the Paper?

Wet slick paper to remove some of the sizing and create more texture. Some papers dry flat, but others buckle and need to be stretched. Tape or staple the damp paper to a board and let dry.

Add a light watercolor glaze to change a paper's texture and make it more receptive to colored pencil.

Cover small areas with a layer of colorless blender to fill in some of the tooth before adding color.

Burnish the paper before you apply color. Lay a piece of tracing or thin paper over the drawing surface and burnish with a bone or wood burnisher. This flattens the tooth of the paper.

LIFTED PAPER FIBERS
If fibers are stubborn, brush them so they stand up, then apply the same color, a colorless blender, white or a lighter color to the paper beneath to use as a "glue."

Gently press fibers back into place with a blender or clean sheet of tracing paper. Apply color as needed to blend with surrounding areas.

SCRATCHES
If a scratch shows up in your drawing, fill it in with colorless blender and then apply more color.

DARK SPOT
Don't add any more color to the dark spot itself.

Sharpen the pencil and apply color around the dark area. You'll be surprised at how quickly the dark spot disappears and blends into the surrounding area.

How Do I Remove a Stain?

First, touch the stain with a moist cotton swab and blot with a dry swab or a paper towel, pressing the paper fibers down. If the stain is stubborn, moisten the cotton swab with chlorine bleach and dab the area. Immediately redab with another swab and clean water. Press the area with a clean paper towel to absorb as much moisture as possible. This method is amazingly effective, but too much bleach will break down fibers, weakening the paper, so use sparingly.

How Do I Hide a Stain?

Dry stains can usually be removed with an eraser because they rest on the top of the paper's tooth, but a wet stain is absorbed into the paper fibers and has to be covered or hidden in some way. White colored pencil won't work because it is semitransparent, so you must hide or cover the stain with an opaque medium.

You'll have to use camouflage. If you stain an area that you have already colored with pencil, you'll find that pencil wax tends to resist moisture. Lightly blot the area with a dampened tissue or paper towel to remove as much of the stain as possible. You may be surprised at the amount of color that you can remove in this manner (even after it dries), because it rests on top of the wax and is not absorbed into the paper.

At this point, you have two choices. You can use a brush to actually apply some of the stain liquid to the surrounding area so that it is all the same color, or you can select colored pencils that match the stain color and layer them around the stain.

demonstration | **hiding stains**

FAINT STAIN ON WHITE

1 REMOVE AS MUCH COLOR AS POSSIBLE
The stain (raspberry juice) has been lightly blotted with a damp paper towel to remove as much color as possible. Allow the paper to dry. Spray with workable fixative

2 APPLY OPAQUE WHITE
Select an opaque white medium (Schwan Stabilo White pencil, white soft pastel stick or white acrylic paint) and apply it directly to the stain with light feathered strokes.

3 COLOR THE AREA AROUND THE STAIN
If the stain is still evident, respray the area to set the white medium. Lightly color the area around the stain with pencils that are similar to the stain. Work the color down into the tooth. Here I used Rosy Beige and Blue Violet Lake layered around the stain and lightly over it.

STAIN ON COLOR

COFFEE STAIN
This coffee stain's edges are darkened with concentrated color.

1 BLOT THE STAIN
Use a damp paper towel to remove as much of the stain color as possible.

2 OPTION ONE
Use a paintbrush to apply coffee to the area around the stain. Blot with a paper towel to even the color.

2 OPTION TWO
Select a colored pencil that closely matches the coffee stain (Brown Ochre [PC]), and color the surrounding area.

HOW DO I MAKE LACE?

There's no doubt about it—lace is compli-
cated. But once you analyze and break
down what's happening, it gets easier.

Repeating Pattern of Holes

Lace is a piece of flat fabric that has a repeat-
ing pattern of holes in it. The pattern can
vary from open (with lots of holes separated
by single threads—very lacy) to more solid
(where the holes are separated by bundles of
threads—crocheted). In the case of cutwork,
some of the holes are separated by areas of
fabric rather than by threads.

Changes in Contour of the Fabric

Unless the lace fabric is lying completely
flat, the pattern of holes will be affected by
the changes in the fabric's contour. The
hills and valleys may cause the holes to
overlap or to look flattened and elongated
as they are affected by perspective.

Shadows on the Fabric

As the surface of the lace fabric changes
from flat to curved or contoured, shadows
develop on the lace fabric itself. Where the
surface curves away from the light source, it
will be darker.

Shadow Cast Onto the Surface Beneath the Lace

The lace casts its own shadow onto the sur-
face below it. Through some of the holes,
you can see the shadow pattern of the lace
cast on the surface underneath. If the surface
is flat (like a counter or tabletop), its local
color will not vary. If it is contoured (as a
piece of colored fabric), it too will change
color or value as its surface changes—and its
contours won't exactly mimic the contour
changes in the lace fabric.

materials list

Surface
Fabriano Uno HP 140-lb. (300gsm)

Pencils
Black Cherry
Crimson Lake
Scarlet Lake
Greyed Lavender
Limepeel
Blue Violet Lake

demonstration | lace

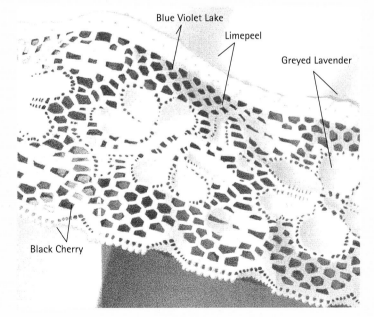

Blue Violet Lake

Limepeel

Greyed Lavender

Black Cherry

1 CREATE THE SHADOW VALUES

Once you have com-
pleted a sketch of this
lace (see page 125), use
Black Cherry to suggest
the shadows cast on
the red fabric surface
under the lace. The val-
ues change from light
to dark. Indicate the
diagonal ridge in the
fabric by a relatively
abrupt change in value.

2 COLOR THE FABRIC

First apply Crimson Lake and then Scarlet Lake over
the Black Cherry to establish the local color of the
red fabric. Use heavier pressure in the darker areas.

3 ESTABLISH THE CONTOURS OF THE LACE FABRIC

First, use Greyed Lavender to indicate the changes
in value on the surface of the lace fabric. Use heav-
ier pressure where the shadows are darker. Next,
apply Limepeel right over all the Greyed Lavender in
the same manner. Last, apply Blue Violet Lake over
the Limepeel and the Greyed Lavender. By using
this combination of colors, you will create your own
warm gray. It is a much more colorful way of mak-
ing shadows than using just a gray pencil.

HOW DO I CREATE THE INTRICACY OF A BASKET?

materials list

Surface
 Rising Stonehenge White

Pencils
 Black Grape
 Terra Cotta
 Pumpkin Orange
 Goldenrod
 Tuscan Red

Baskets are challenging because they usually have several directional patterns. Take time to understand the basic construction to identify and follow the materials as they weave, twine or overlay one another.

demonstration | **woven basket**

1 DARKEST AREAS
Once you have completed the line drawing of this basket (see page 126), begin applying Black Grape in the darkest areas. Use several layers or heavier pressure for dramatic shadows.

2 MIDTONES
Still using the Black Grape, apply a lighter touch or fewer layers of color for the midtones to complete the interior of the basket.

3 COMPLETE THE FOUNDATION
Work the form of the outside of the basket in a full range of values with Black Grape.

4 ADD COLOR
Add Terra Cotta and Pumpkin Orange to the diagonal strips of material, starting on the interior of the basket.

Uncolored white paper indicates open spaces in basket construction.

Tuscan Red

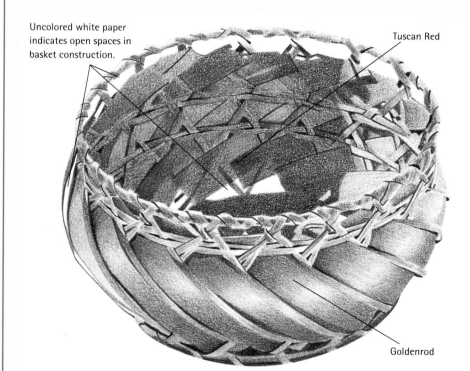

Goldenrod

5 FINISHING TOUCHES
Continue the Pumpkin Orange and Terra Cotta layers on the outside of the basket. Use consistent, evenly applied color to make the diagonal strips look lacquered and smooth. Gradate color smoothly to leave a highlighted area on each strip to make it appear rounded for the bowl-shaped basket, applying a light layer of Goldenrod over the bare white highlights. Apply some Tuscan Red in the shadows to warm and enrich those dark areas.

WHAT HELPS STRIPED FABRIC LOOK BELIEVABLE?

materials list

Surface
Rising Stonehenge White

Pencils
French Grey 30%
French Grey 50%
Indigo Blue
Black
Crimson Red
Tuscan Red

Stripes need to be believable in placement but not so perfect that they look mechanical and static. To create lively but correctly arranged stripes on fabric, you'll need to take an extra preparation step called a contour drawing to fully understand the form of the cloth.

demonstration | striped fabric

1 CONTOUR DRAWING

Once you've completed a line drawing of this piece of fabric (see page 126), draw in parallel lines following the folds, hills and valleys of the fabric.

2 PRELIMINARY SKETCH

Place a sheet of tracing paper over the contour drawing. Trace the shirt's outline and the contour lines that you will need as placement for your stripes. Add or eliminate stripes as needed. Indicate major shadows with dotted lines.

3 BUILD FORM AND VOLUME

Transfer your preliminary sketch onto your drawing paper. Build form and volume with French Grey 30% and 50%. Pay careful attention to the subtleties of light and shadow to make the fabric appear fluid and lively.

4 COLOR THE STRIPES

Use Indigo Blue, Black, Crimson Red and Tuscan Red to color the stripes. Use a sharp point so your stripes are relatively uniform in width. Make the stripes darker in the shadows. This change in value helps define the movement of the fabric.

HOW DO I MAKE FRINGE?

Fringe is a lot like lace: It's the holes or negative areas that get most of your effort and attention. But it's also important not to lose sight of the strands and what they do. When you draw the fringe, draw the topmost strands first because you can see all of each one. Then draw those underneath. Stay aware of the negative shapes between them and think of them as positive.

materials list

Surface
Fabriano Uno HP 140-lb. (300gsm)

Pencils
French Grey 50%
Black Cherry
Burnt Ochre
Henna

demonstration | **fringe**

3 COMPLETE THE LOCAL COLOR
Use Henna to cover the already applied Burnt Ochre, and your fringe is complete.

2 BEGIN THE LOCAL COLOR
Apply Burnt Ochre to the entire surface beneath the fringe. Color right over the Black Cherry.

1 GIVE THE STRANDS DEPTH AND DIMENSION
After drawing in this fringe (see page 126), use French Grey 50% to indicate the shadows on the strands themselves. Leave the rest of the strand the white of the paper.

Then, use Black Cherry to color the shadows cast by the fringe onto the surface beneath.

LINE DRAWINGS FOR DEMONSTRATIONS

These line drawings are for you. This book is not about drawing, it's about coloring. You have permission to copy and enlarge any or all of these drawings. We want you to experience the joy of colored pencil, and we want to pass on our love of it to you.

Brass container from page 73.

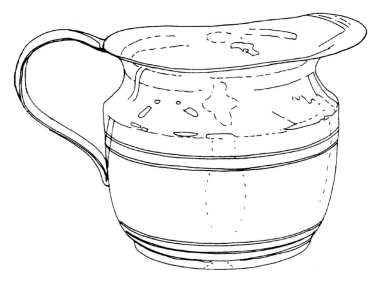

Copper pitcher from page 75.

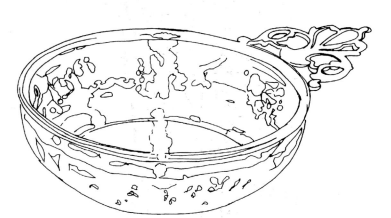

Silver porridge bowl from page 77.

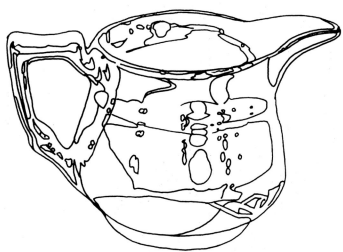

Metallic glaze pitcher from page 79.

Colored glass jar from page 81.

Clear glass on white ground from page 83.

Glass on colored surface from page 85.

Fractured view through water from page 86.

Objects distorted in water from page 90.

Interesting reflections in water from page 89.

Transparent overlapped cellophane from page 93.

Shiny satin from page 98.

Coarse linen from page 99.

Indian corn from page 100.

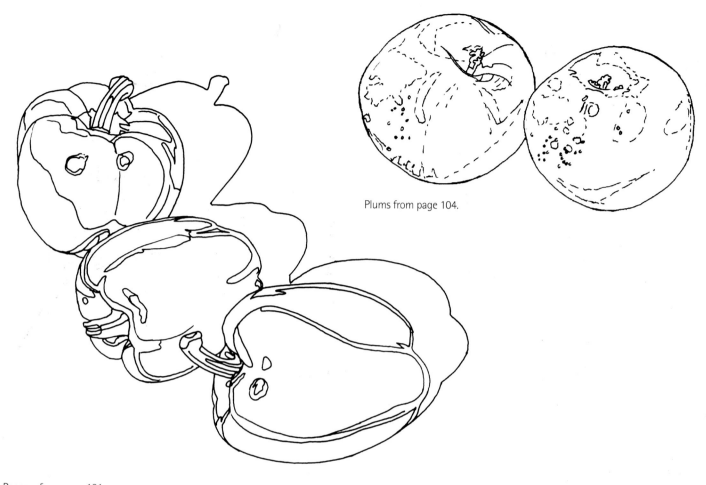

Plums from page 104.

Peppers from page 101.

Peach from page 105.

Rose from page 106.

Sweet pea from page 107.

Daylily from page 108.

Lace from page 115.

Basket from page 116.

Striped fabric from page 118.

Fringe from page 119.

INDEX

INDEX